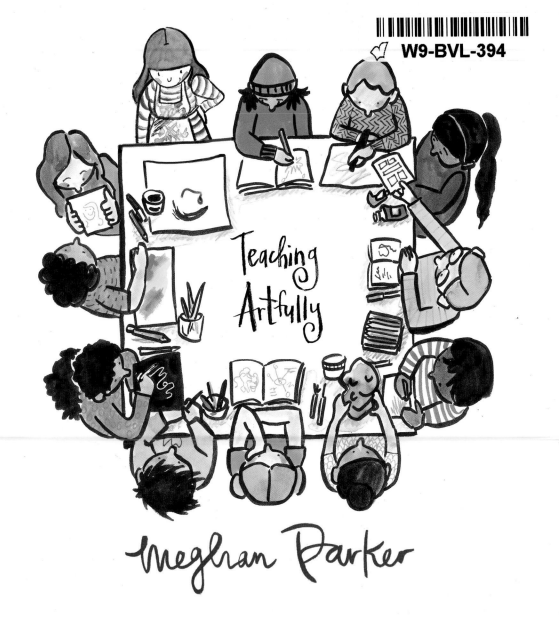

Teaching Artfully

Meghan Parker

Book Production by Robbie Robbins

Editor Craig Yoe

Publisher Ted Adams

"I keep buying Yoe Books as gifts then
keeping them for myself! Visit YoeBooks.com"
— Mark Hamill/Tweet

www.YoeBooks.com

twitter: @YoeBooks

facebook: /YoeBooks

instagram: @YoeBooks

Yoe Books Co-Creative Directors:
Clizia Gussoni and Craig Yoe

www.CloverPress.us

twitter: @Clover_Press

facebook: /CloverPress US

instagram: @Clover_Press

Clover Press Founders:
Ted Adams, Elaine LaRosa,
Nate Murray, Robbie Robbins

FIRST PRINTING JANUARY 2021
ISBN: 978-1-951038-20-5

4 3 2 1 21 22 23 24

TEACHING ARTFULLY TPB. Teaching Artfully ©2021
Meghan Parker, Yoe Books, and Clover Press, LLC.
All Rights Reserved.

Editorial offices: 12625 High Bluff Dr. San Diego, CA
92130. The Clover Press logo is registered in the U.S.
Patents and Trademark Office.
 Yoe Books (R) is a registered trademark of
Gussoni-Yoe Studio, Inc.

A grateful thanks to these experts for their
invaluable help: Julie Case, Randall Cyrenne
Mark Laser, Chris Mostyn, Erich Parker,
Tony Rose, Peter Sanderson, Bill Stewart,
Anne Telford, Steven Thompson and
Carol Tilley.

For book sales please contact Diamond Book Distributors: books@diamondcomics.com

for my student artists

I would like to thank
the Coast Salish people, specifically
the Skwxwú7mesh Nation and
Tsleil-Waututh Nation, upon whose
unceded traditional territory North
Vancouver resides. I am grateful for
the opportunity to live, work, play
and learn in this place.

Acknowledgements

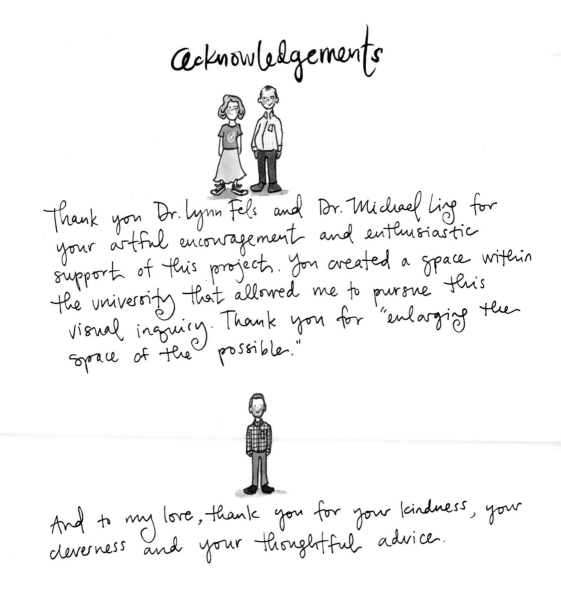

Thank you Dr. Lynn Fels and Dr. Michael Ling for your artful encouragement and enthusiastic support of this project. You created a space within the university that allowed me to pursue this visual inquiry. Thank you for "enlarging the space of the possible."

And to my love, thank you for your kindness, your cleverness and your thoughtful advice.

Foreword

by Nick Sousanis

Delight.

Delight is the first word that springs to mind in spending time with Meghan Parker's *Teaching Artfully*. The delight in observing her avid curiosity as she explores her own learning. Delight in the ways that she goes about making meaning throughout these inventive and playful pages. The delight she takes in the act of making itself. It's infectious, and each page that she's carefully and exuberantly composed is abundantly infused with it.

Parker takes us on a metaphorical journey of an educator exploring teaching and an artist exploring her craft. By making her quest in comics, she demonstrates that art and scholarship not only don't have to be separate, but in fact, they are stronger when we do them in tandem.

When making my dissertation in comics, which kindly makes an appearance in these pages, I was less concerned with its firstness and more concerned with making sure it wouldn't be the *last* of its kind. I was determined that its existence would help open spaces for more things to come. Thus I was extremely intrigued to learn of Parker's thesis while it was still in process, and so pleased with what she created and the deservedly enthusiastic response it received. And I'm thrilled that it's now published and you, and I, can hold it in our hands. I'm confident that Parker's work will continue to cement the reality that using comics in these settings will soon no longer be an exception, but rather one of the many varied ways that people explore their learning and express their understanding.

That learning should be an excursion, a celebration of the things that make us human— delight—is embodied in Parker's explorations on these pages. She draws and employs the comics form as a way to ask questions and to uncover things she couldn't come to learn by other means. Through her drawings, Parker brings us alongside her on her journey, as we come to know her as educator, as artist, as human filled with questions always willing to dive into the depths to see where they lead. It's an enriching experience, and one that is sure to spark educators to create new spaces for learning in their classrooms.

Prepare to be delighted—and to find yourself inspired on each page by Parker's relentless imagination to dive in and make explorations of your own.

Nick Sousanis *is an Eisner-winning comics maker and an associate professor in Humanities & Liberal Studies at San Francisco State University, where he runs an interdisciplinary Comics Studies program. He is the author of* Unflattening, *originally his doctoral dissertation, which he wrote and drew entirely in comics form. His comics have appeared in* Nature, *the* Boston Globe, *and* Columbia Magazine.

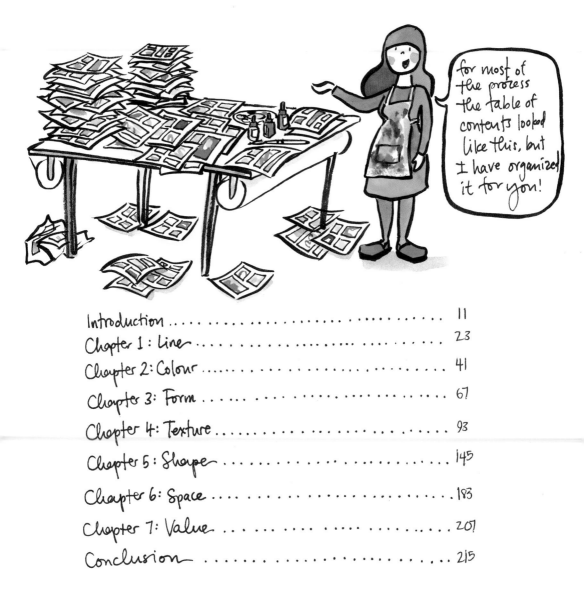

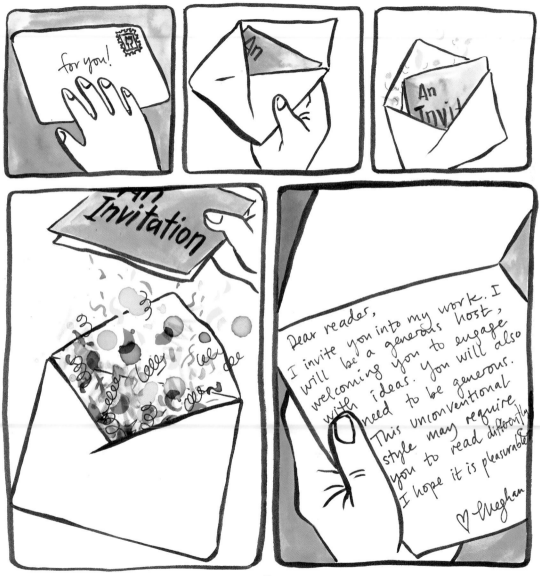

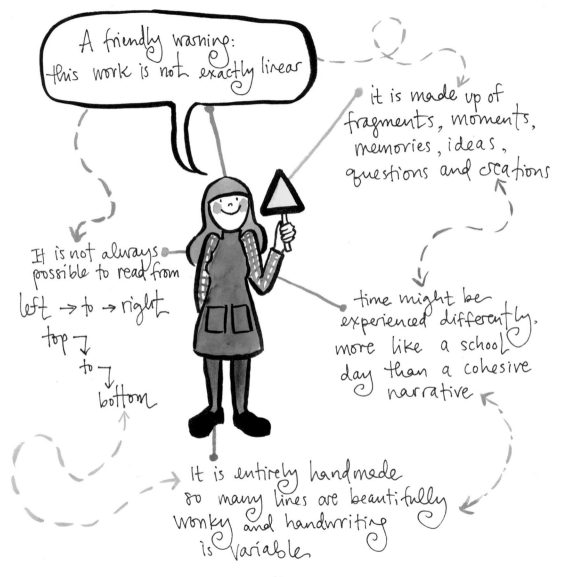

12

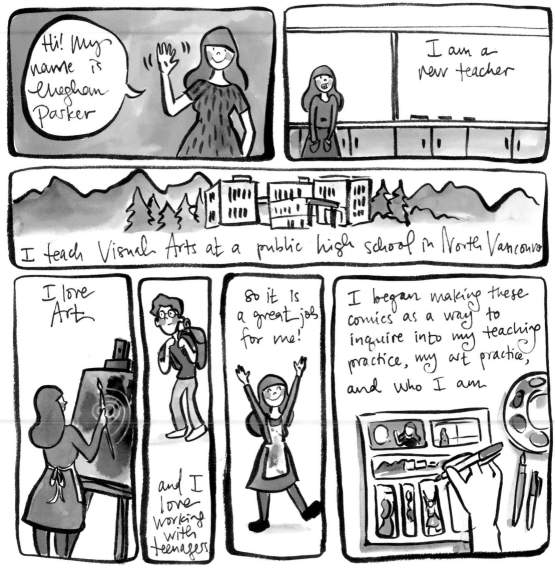

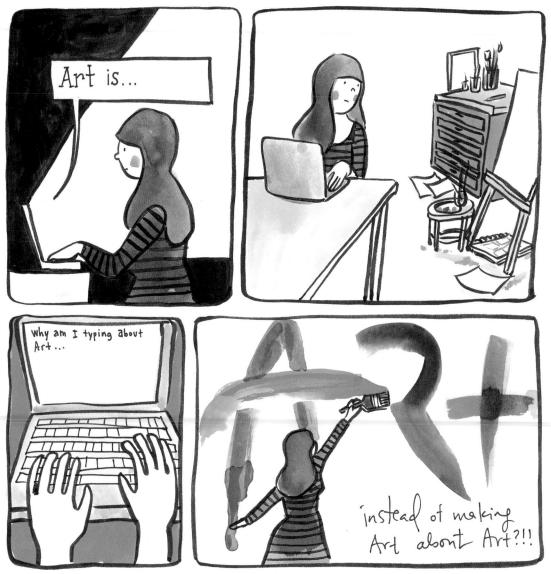

15

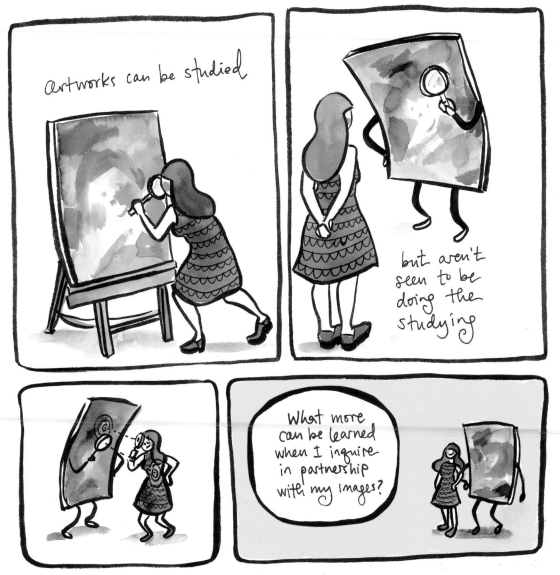

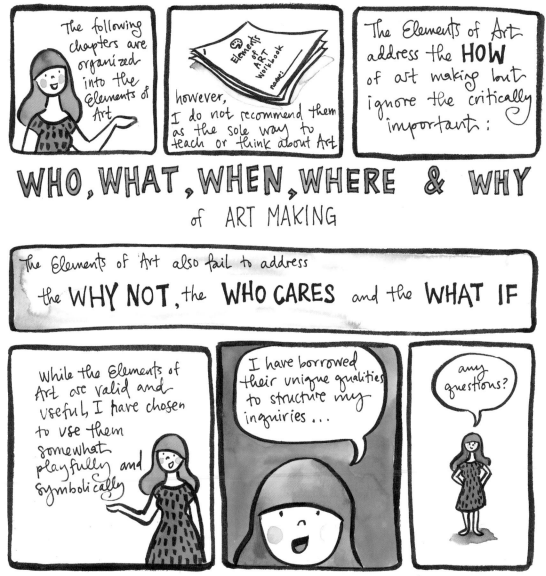

WHO, WHAT, WHEN, WHERE & WHY
of ART MAKING

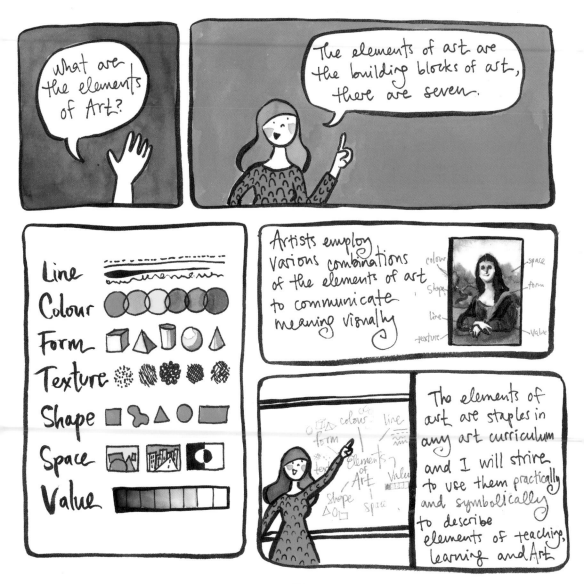

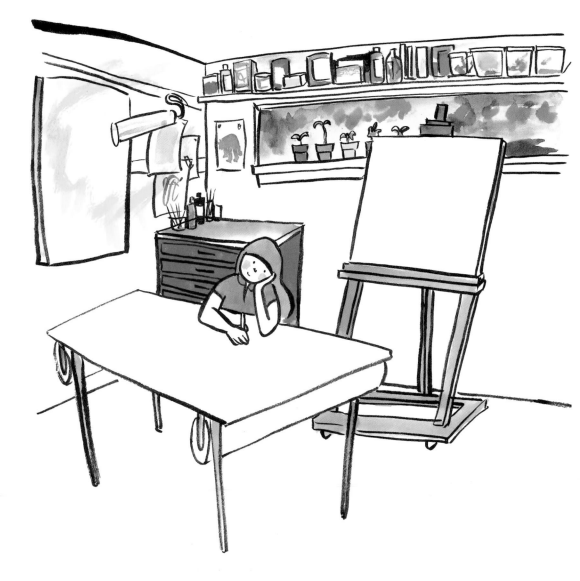

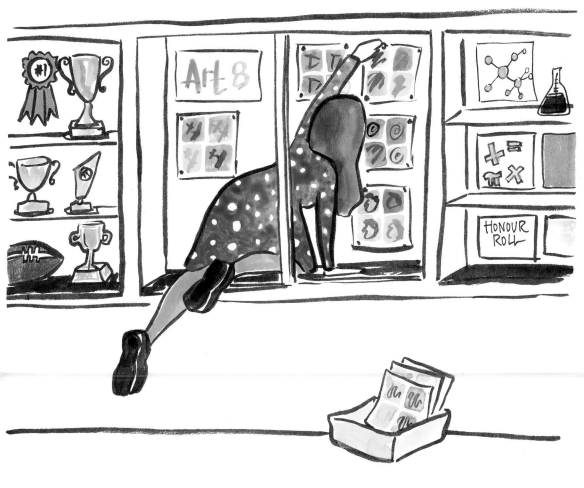

Line

Line is the element of art described as a point in motion. I thought following a line of inquiry would be simple...

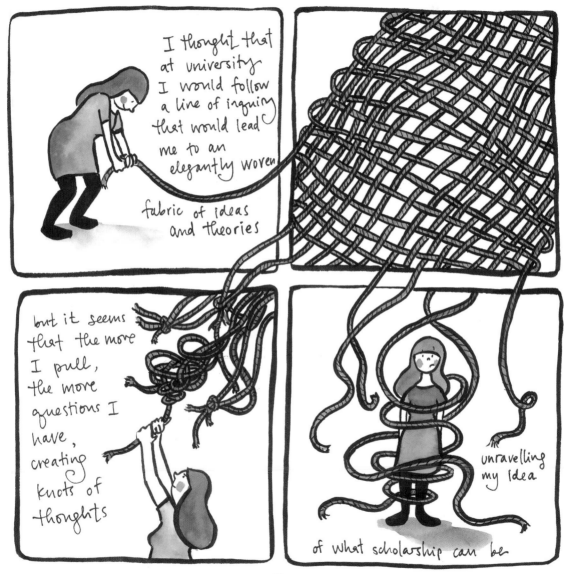

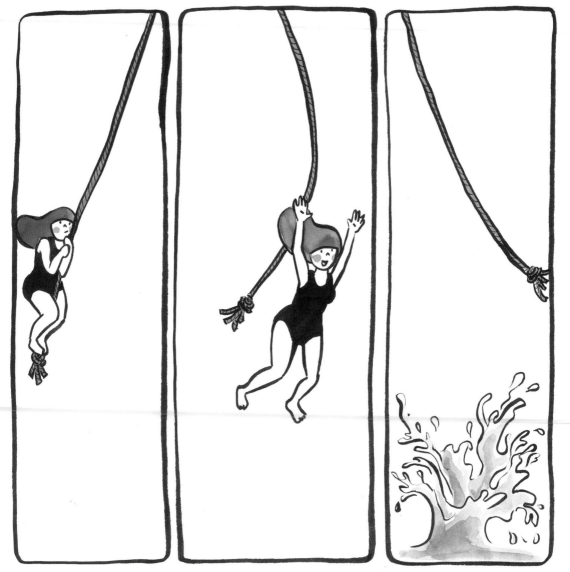

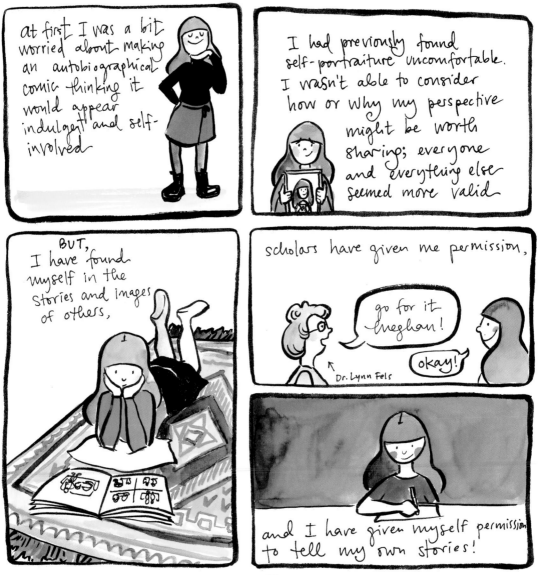

at first I was a bit worried about making an autobiographical comic thinking it would appear indulgent and self-involved

I had previously found self-portraiture uncomfortable. I wasn't able to consider how or why my perspective might be worth sharing; everyone and everything else seemed more valid

BUT, I have found myself in the stories and images of others,

scholars have given me permission,

go for it meghan!

Dr. Lynn Fels

okay!

and I have given myself permission to tell my own stories!

26

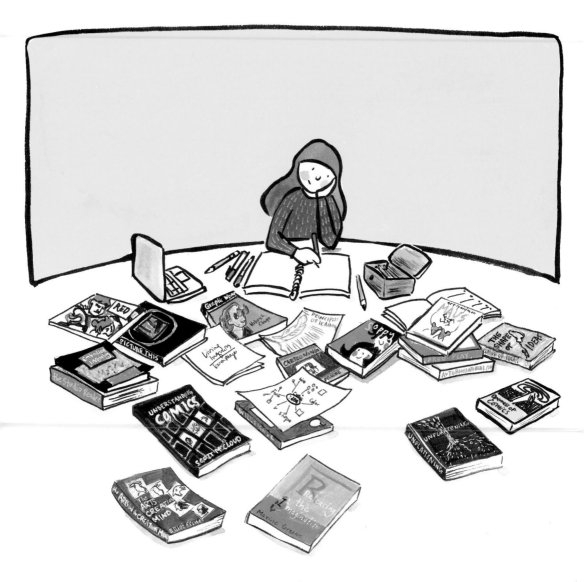

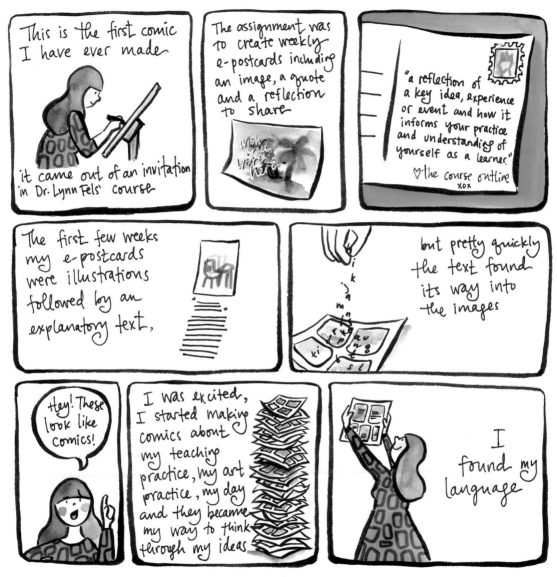

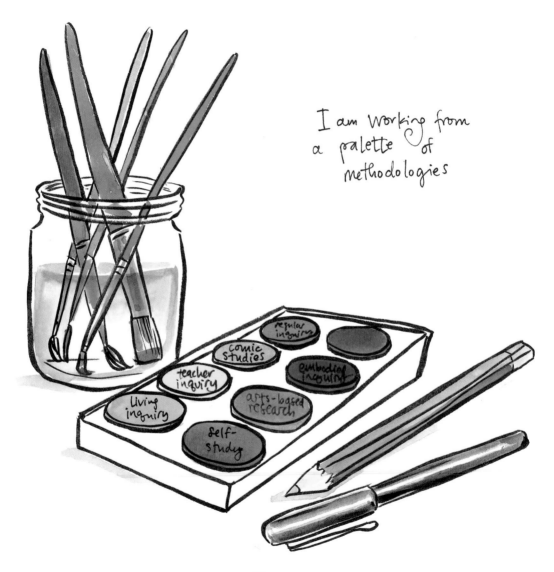

I am working from
a palette of
methodologies

regular inquiry

comic studies

embodied inquiry

teacher inquiry

arts-based research

living inquiry

self-study

why self-study?

- carefully examine teaching practice
- using art practice to develop deeper understandings
- exploring scholarship in and through teaching
- enhance student learning

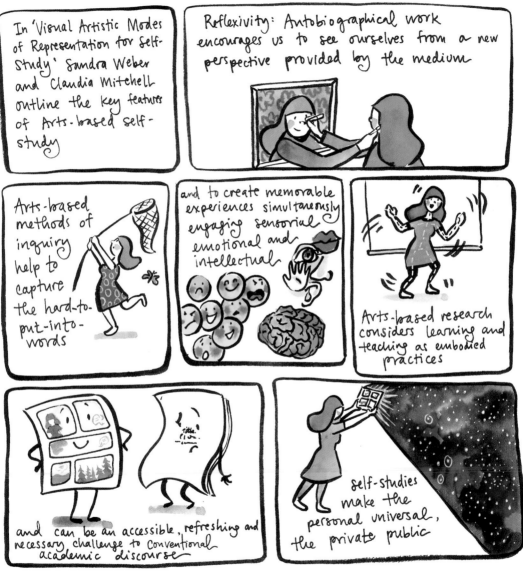

In 'Visual Artistic Modes of Representation for Self-Study' Sandra Weber and Claudia Mitchell outline the key features of Arts-based self-study

Reflexivity: Autobiographical work encourages us to see ourselves from a new perspective provided by the medium

Arts-based methods of inquiry help to capture the hard-to-put-into-words

and to create memorable experiences simultaneously engaging sensorial emotional and intellectual

Arts-based research considers learning and teaching as embodied practices

and can be an accessible, refreshing and necessary challenge to conventional academic discourse

Self-studies make the personal universal, the private public

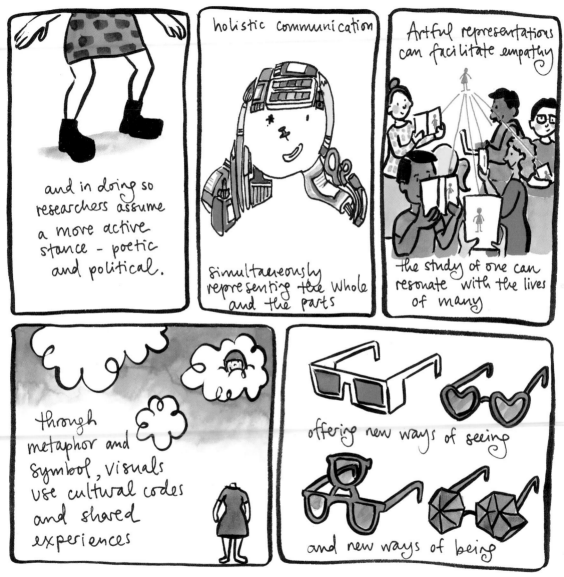

and in doing so researchers assume a more active stance - poetic and political.

holistic communication

simultaneously representing the whole and the parts

Artful representations can facilitate empathy

the study of one can resonate with the lives of many

through metaphor and symbol, visuals use cultural codes and shared experiences

offering new ways of seeing

and new ways of being

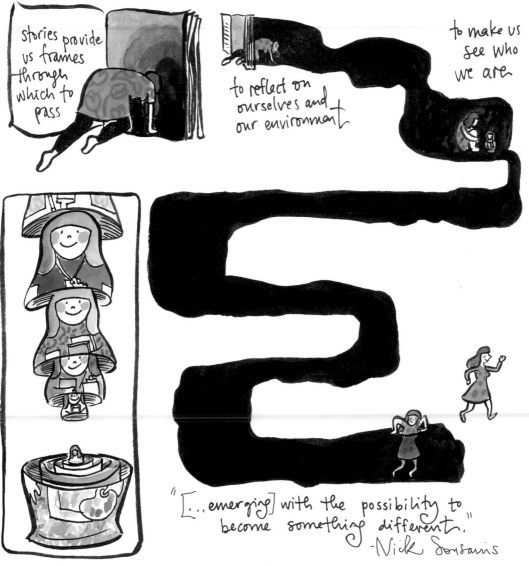

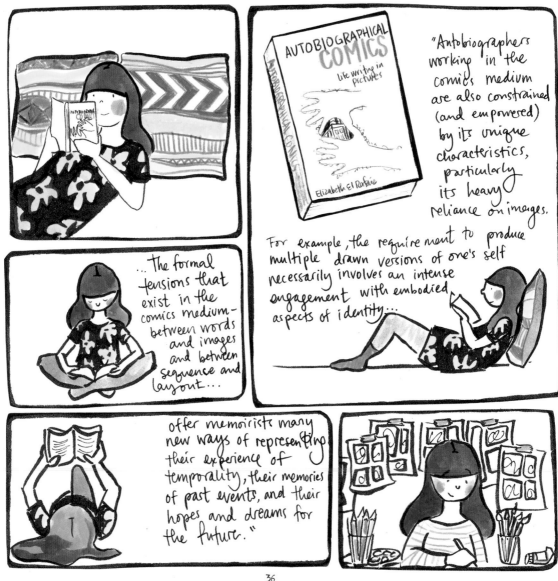

AUTOBIOGRAPHICAL COMICS
Life writing in Pictures

Elizabeth El Refaie

"Autobiographers working in the comics medium are also constrained (and empowered) by its unique characteristics, particularly its heavy reliance on images.

For example, the requirement to produce multiple drawn versions of one's self necessarily involves an intense engagement with embodied aspects of identity...

... The formal tensions that exist in the comics medium— between words and images and between sequence and layout...

offer memoirists many new ways of representing their experience of temporality, their memories of past events, and their hopes and dreams for the future."

36

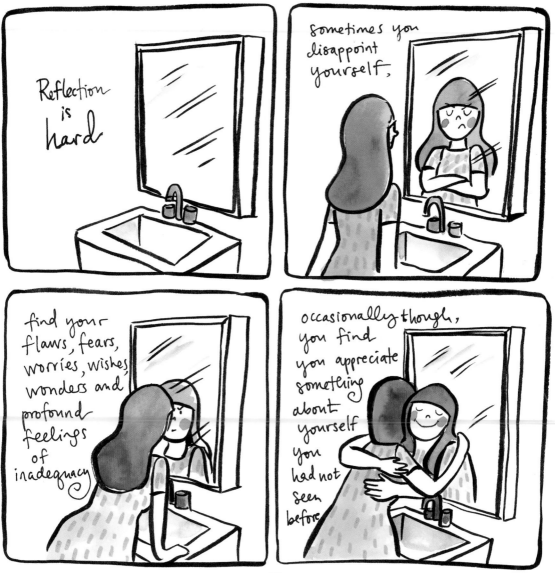

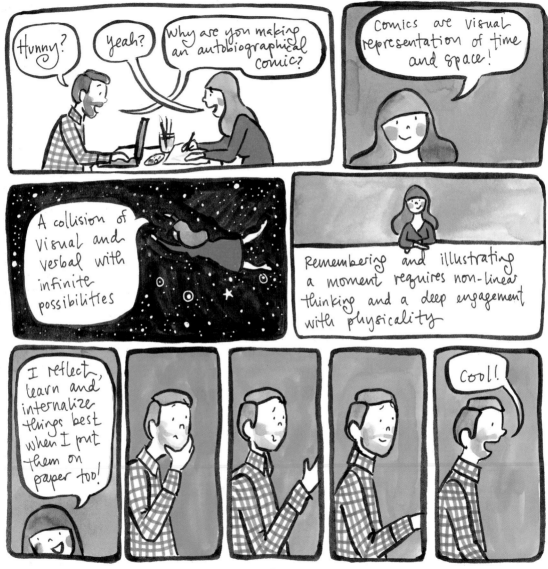

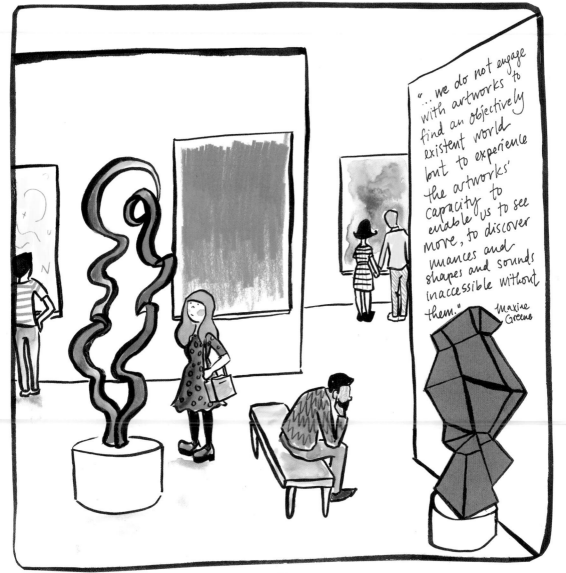

Colour

Colour is the element of art
that refers to the spectrum of visible
light. The light brought into our lives
through experiences in the arts is not
always visible (or measurable),
but it is critically important
for our well being.

"Think of [life] as a page. The main text is central, it is the text of need, of food and shelter, of daily pre-occupations and jobs, keeping things going... so long as we are in this text, we merely coincide with our ordinary selves"
— Denis Donoghue
via Maxine Greene

Donoghue suggests that the arts are on the margins of most people's lives

"a place for those feelings and intuitions which daily life doesn't have a place for and mostly seems to suppress."

and in living "within the arts" we make spaces for ourselves to experience empathy and to be present and attentive to the beauty found in the margins

we must also invite students to make space for themselves

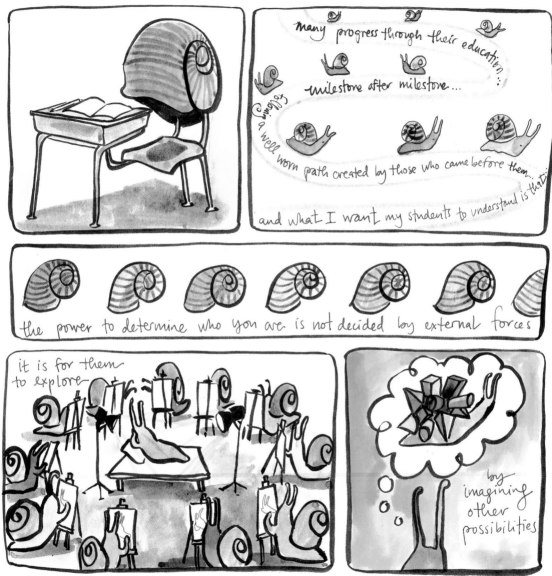

Many progress through their education... milestone after milestone... following a well worn path created by those who came before them...

and what I want my students to understand is that:

the power to determine who you are is not decided by external forces

it is for them to explore—

by imagining other possibilities

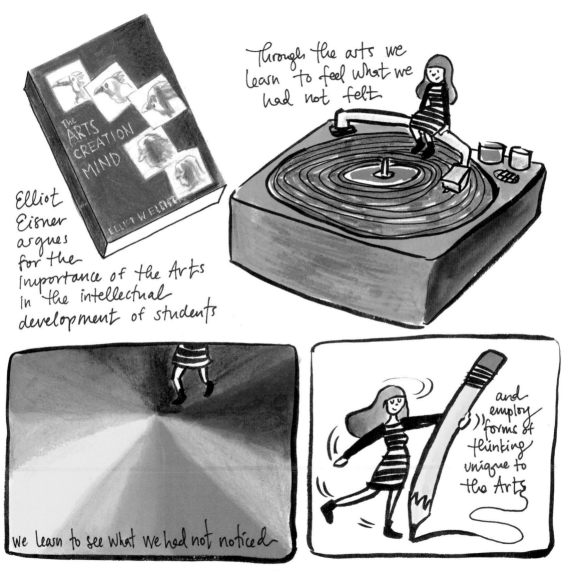

The ARTS CREATION MIND

ELLIOT W. EISNER

Elliot Eisner argues for the importance of the Arts in the intellectual development of students

Through the arts we learn to feel what we had not felt

we learn to see what we had not noticed

and employ forms of thinking unique to the Arts

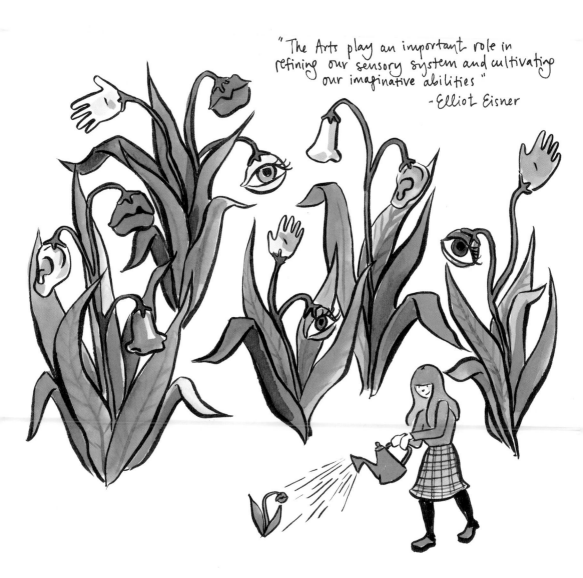

"The Arts play an important role in refining our sensory system and cultivating our imaginative abilities"
 -Elliot Eisner

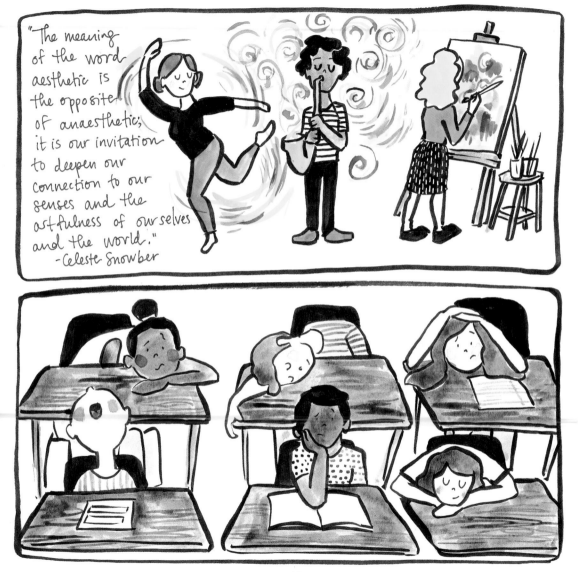

"The meaning of the word aesthetic is the opposite of anaesthetic; it is our invitation to deepen our connection to our senses and the artfulness of ourselves and the world."
-Celeste Snowber

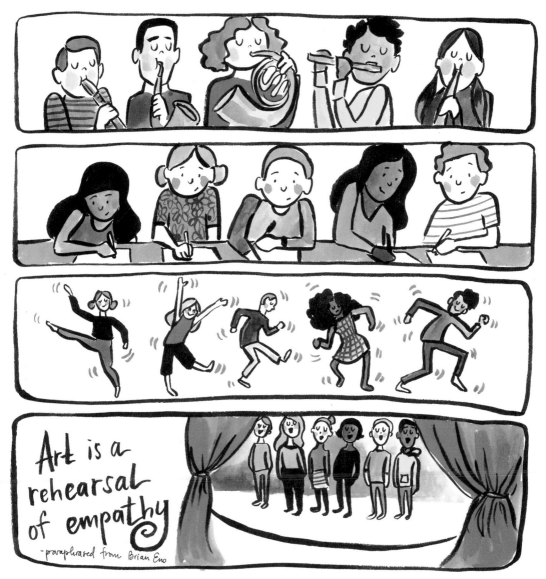

Art is a
rehearsal
of empathy
- paraphrased from Brian Eno

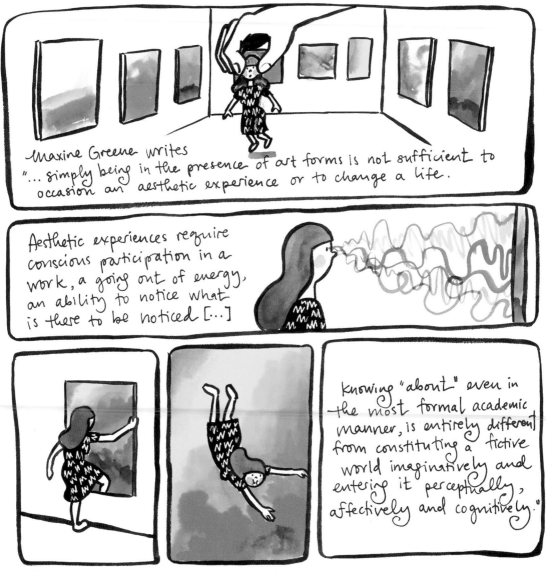

Maxine Greene writes

"... simply being in the presence of art forms is not sufficient to occasion an aesthetic experience or to change a life.

Aesthetic experiences require conscious participation in a work, a going out of energy, an ability to notice what is there to be noticed [...]

Knowing "about" even in the most formal academic manner, is entirely different from constituting a fictive world imaginatively and entering it perceptually, affectively and cognitively."

51

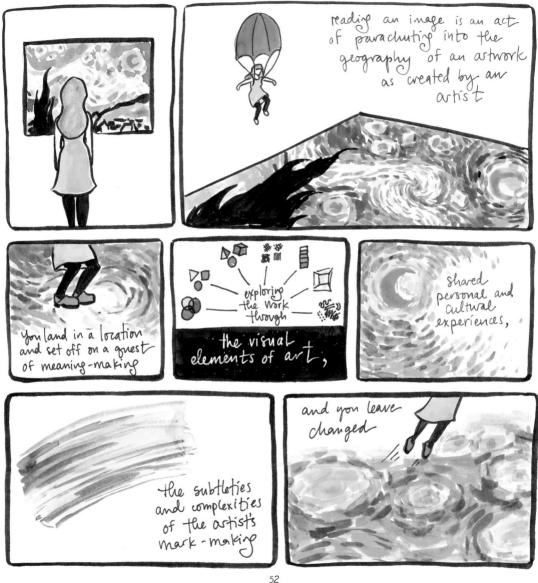

reading an image is an act of parachuting into the geography of an artwork as created by an artist

You land in a location and set off on a quest of meaning-making

exploring the work through

the visual elements of art,

shared personal and cultural experiences,

the subtleties and complexities of the artist's mark-making

and you leave changed

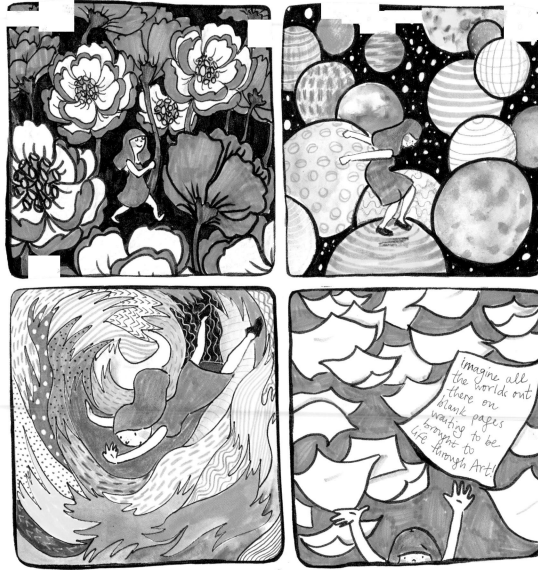

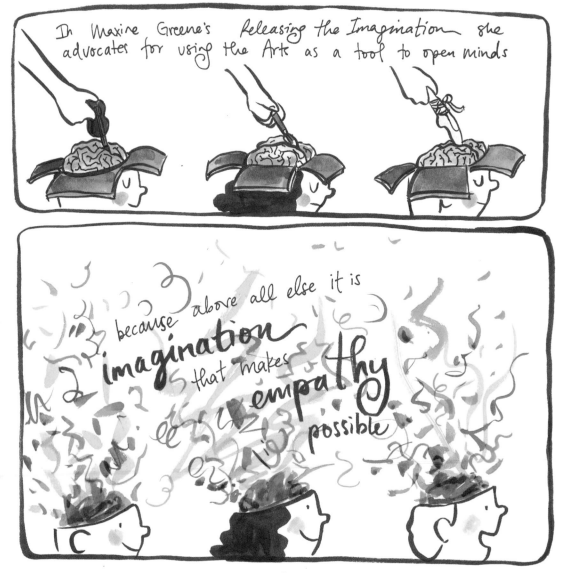

In Maxine Greene's *Releasing the Imagination* she advocates for using the Arts as a tool to open minds

because above all else it is *imagination* that makes *empathy* possible

55

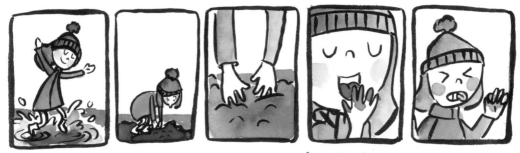

As childen we are deeply engaged with all of our senses, our knowledge is in our bodies

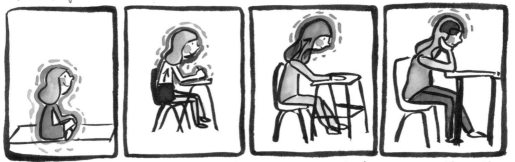

and as we go through school we are increasingly aware that the knowledge gained from our bodies is not as valued as that from our mind

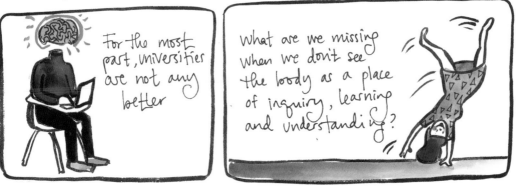

For the most part, universities are not any better

What are we missing when we don't see the body as a place of inquiry, learning and understanding?

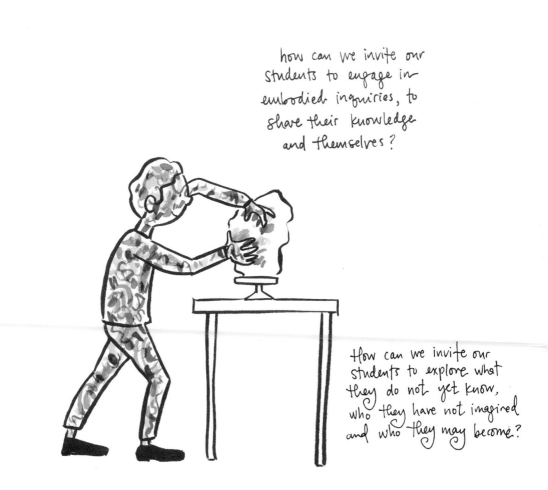

how can we invite our students to engage in embodied inquiries, to share their knowledge and themselves?

How can we invite our students to explore what they do not yet know, who they have not imagined and who they may become?

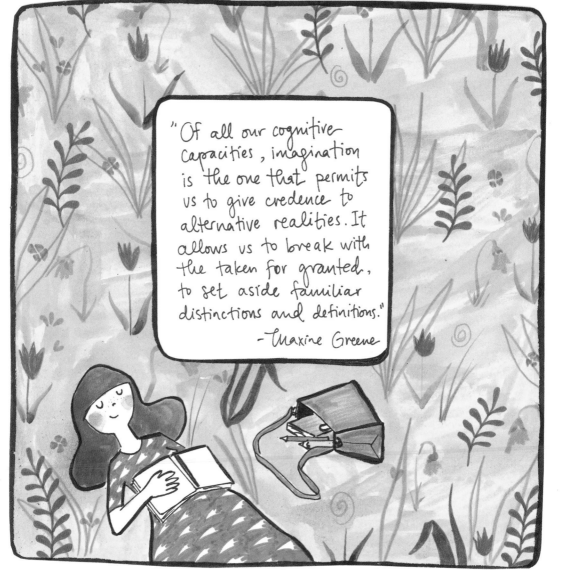

"Of all our cognitive capacities, imagination is the one that permits us to give credence to alternative realities. It allows us to break with the taken for granted, to set aside familiar distinctions and definitions."
— Maxine Greene

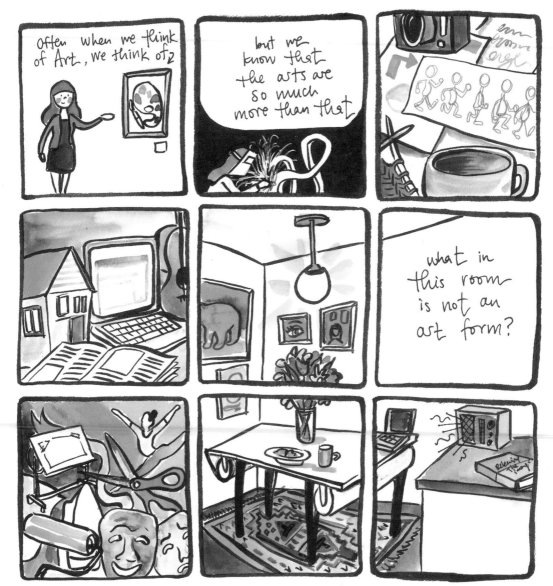

59

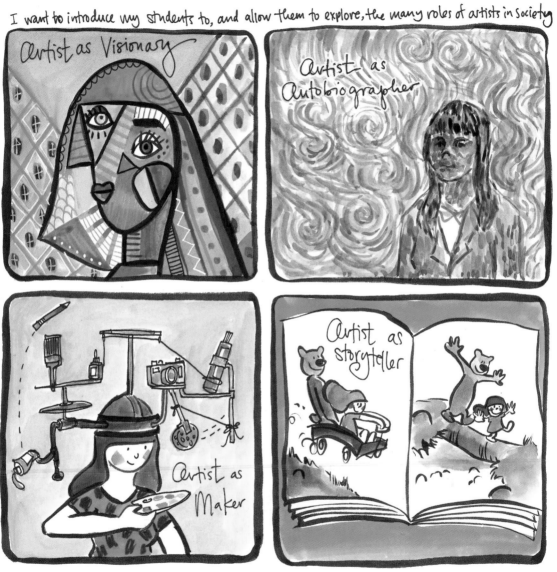

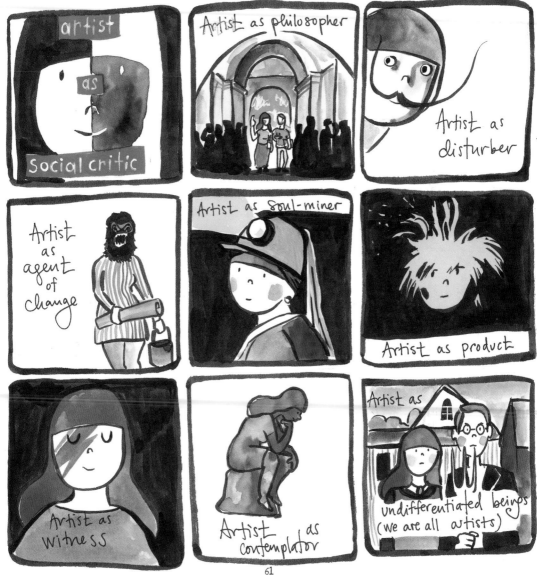

61

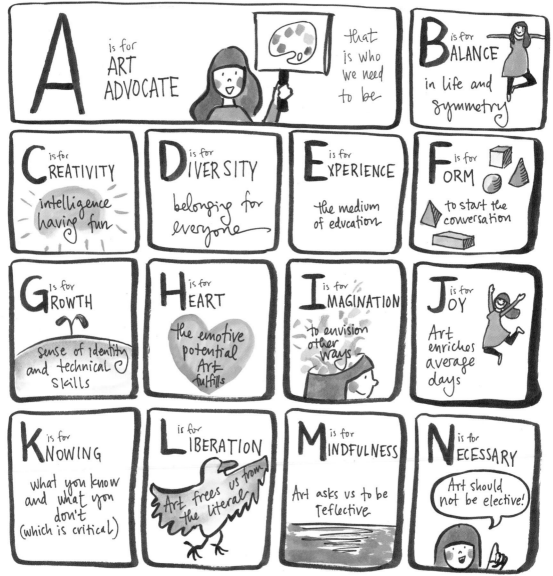

A is for ART ADVOCATE — that is who we need to be

B is for BALANCE — in life and symmetry

C is for CREATIVITY — intelligence having fun

D is for DIVERSITY — belonging for everyone

E is for EXPERIENCE — the medium of education

F is for FORM — to start the conversation

G is for GROWTH — sense of identity and technical skills

H is for HEART — the emotive potential Art fulfills

I is for IMAGINATION — to envision other ways

J is for JOY — Art enriches average days

K is for KNOWING — what you know and what you don't (which is critical)

L is for LIBERATION — Art frees us from the literal

M is for MINDFULNESS — Art asks us to be reflective

N is for NECESSARY — Art should not be elective!

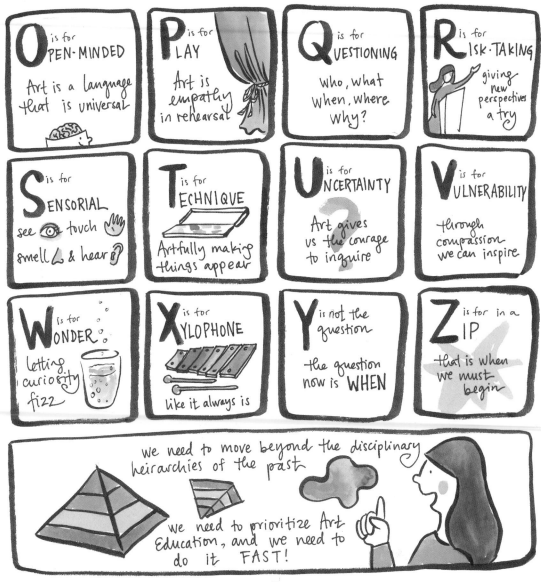

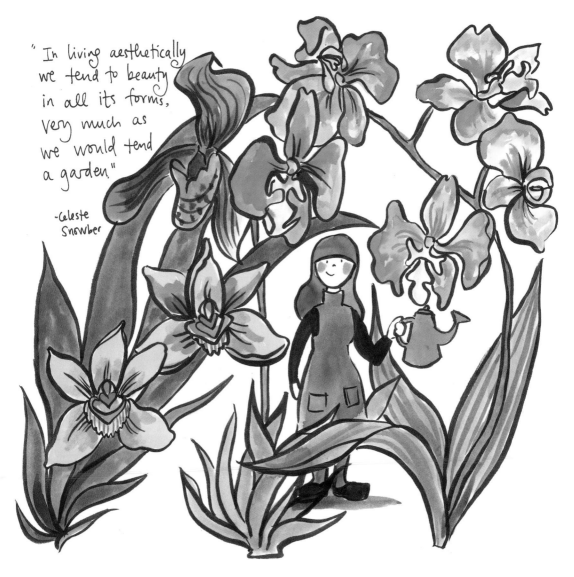

"In living aesthetically we tend to beauty in all its forms, very much as we would tend a garden."

-Celeste Snowber

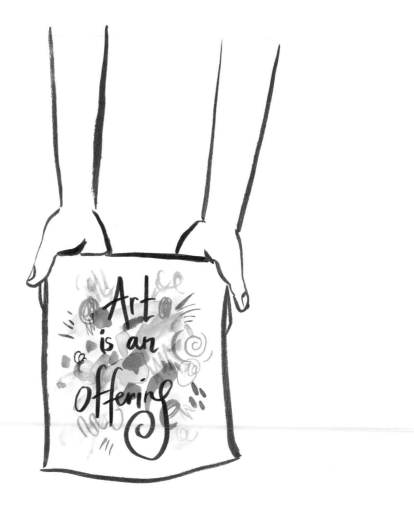

Form is the element of art that deals with the three-dimensional: width height and depth. The form in which we communicate knowledge matters. The qualities of the comic form provide a unique way to communicate; time, space and narrative.

In defense
of the
form

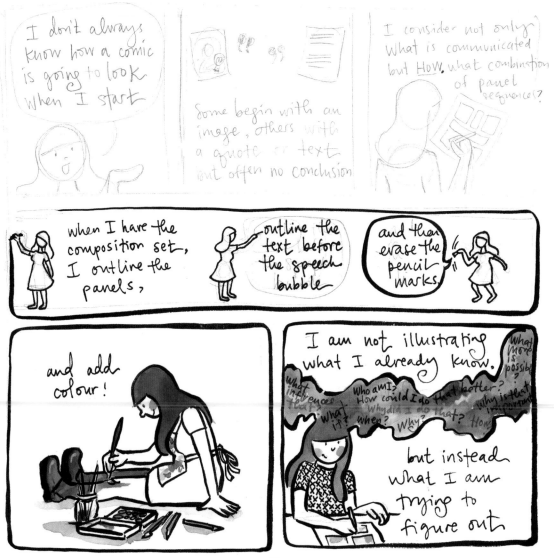

I don't always know how a comic is going to look when I start

Some begin with an image, others with a quote or text but often no conclusion

I consider not only what is communicated but HOW. what combination of panel sequences?

when I have the composition set, I outline the panels,

outline the text before the speech bubble

and then erase the pencil marks.

and add colour!

I am not illustrating what I already know.

What more is possible

What influences that? Who am I? How could I do that better? Why is that important?
what if? when? Why did I do that? Why? How?

but instead what I am trying to figure out

In the book
Openness of Comics
Maaheen Ahmed uses
Umberto Eco's concept
of 'Openness' to explore
how comics generate
meaning

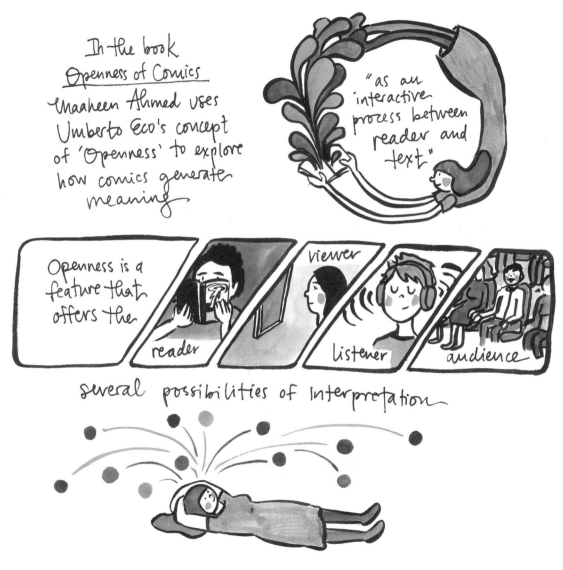

"as an interactive process between reader and text"

Openness is a feature that offers the

reader

viewer

listener

audience

several possibilities of interpretation

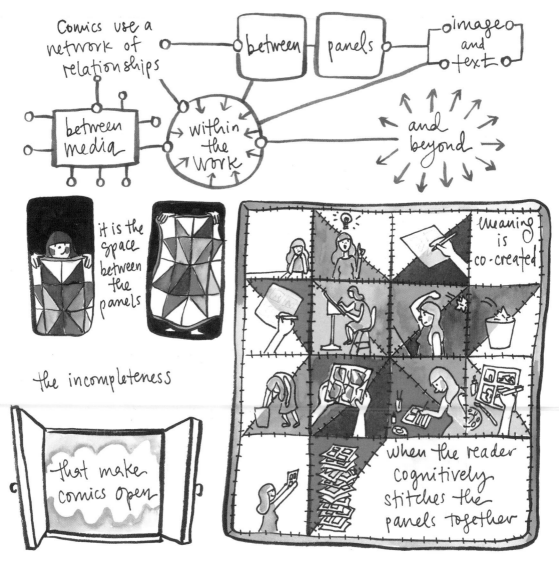

Comics use a network of relationships

between media

within the work

between panels

image and text

and beyond

it is the space between the panels

the incompleteness

that make comics open

meaning is co-created

when the reader cognitively stitches the panels together

71

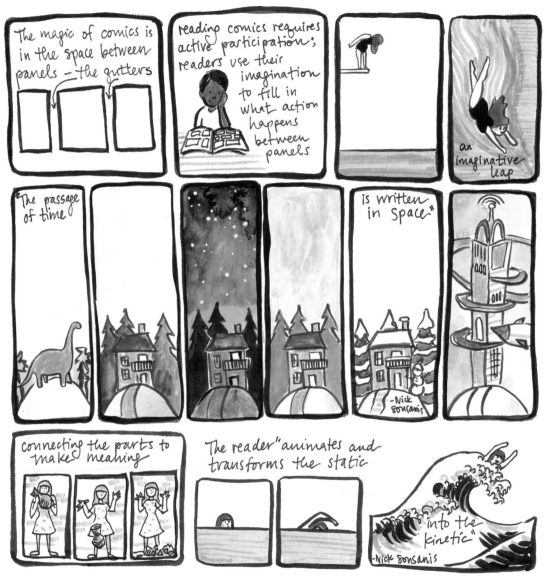

The magic of comics is in the space between panels — the gutters

reading comics requires active participation; readers use their imagination to fill in what action happens between panels

an imaginative leap

"The passage of time"

is written in space"

— Nick Sousanis

connecting the parts to make meaning

The reader "animates and transforms the static

into the kinetic"

— Nick Sousanis

Comics don't have a very 'academic' reputation

As Scott McCloud put it,

Comics were those bright, colourful magazines filled with bad art, stupid stories and guys in tights

In **THE** book about comics, Understanding Comics McCloud presents a different possibility for the medium

Scott McCloud arrives at this definition for comics:

"juxtaposed pictorial and other images in deliberate sequence"

through the comic form, McCloud deconstructs the hidden language of comics and invites us to see the potential of the form, simultaneously showing and telling

reading Understanding Comics was a turning point for me. It cleverly and creatively articulated how and why comic artists use the comic form to convey meaning and narrative.

Articulating the How is key for me as a teacher. The more deeply I come to understand HOW artists and other creators of visual culture use image and text to impact and communicate,

the better able I am to pass these lessons on to my students, making them more critical consumers and creators of visual culture

An artist makes many decisions that influence the meaning of a work

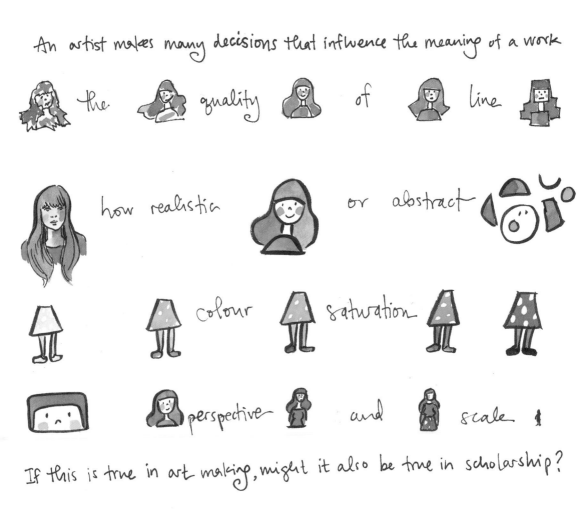

the quality of line

how realistic or abstract

colour saturation

perspective and scale

If this is true in art making, might it also be true in scholarship?

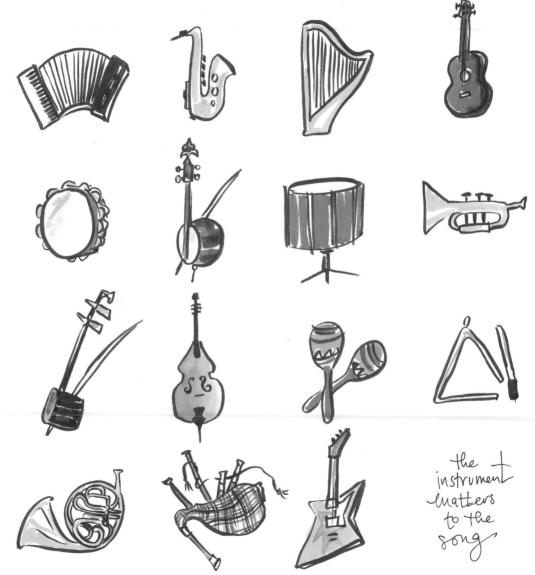

the instrument matters to the song

 A

 ex

the
medium
matters to
the
message

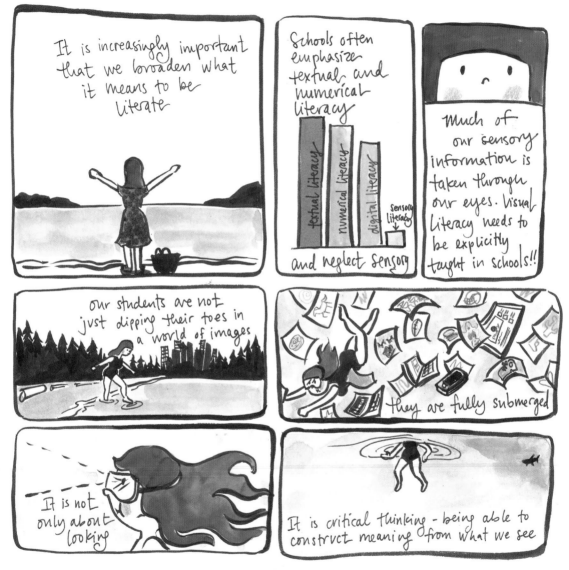

It is increasingly important that we broaden what it means to be literate

Schools often emphasize textual and numerical literacy

textual literacy
numerical literacy
digital literacy
sensory literacy

and neglect sensory

Much of our sensory information is taken through our eyes. Visual literacy needs to be explicitly taught in schools!!

Our students are not just dipping their toes in a world of images

they are fully submerged

It is not only about looking

It is critical thinking - being able to construct meaning from what we see

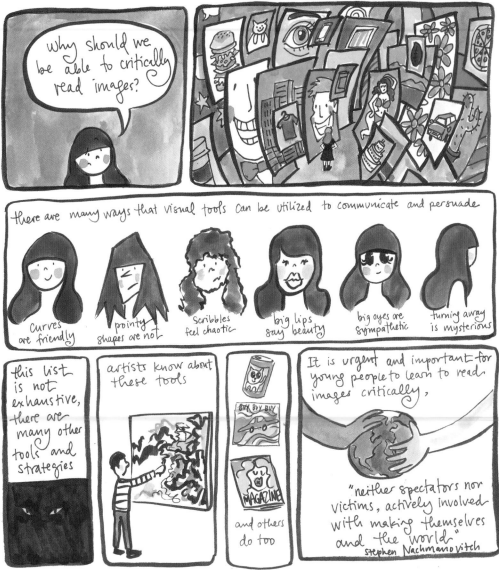

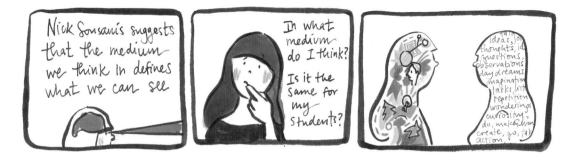

Nick Sousanis suggests that the medium we think in defines what we can see

In what medium do I think? Is it the same for my students?

falling ideas, joy, thoughts, id, questions, observations, daydreams, imagination, tasks, lists, repetition, wonderings, curiosity, do, makes, create, go, action

a connected whole

images have no start or finish

"while the image IS...

...the text is always ABOUT." visual and verbal modes each have distinct structures and patterns of practice

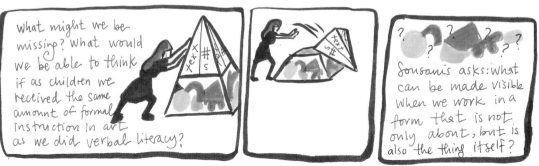

What might we be missing? What would we be able to think if as children we received the same amount of formal instruction in art as we did verbal literacy?

Sousanis asks: what can be made visible when we work in a form that is not only about, but is also the thing itself?

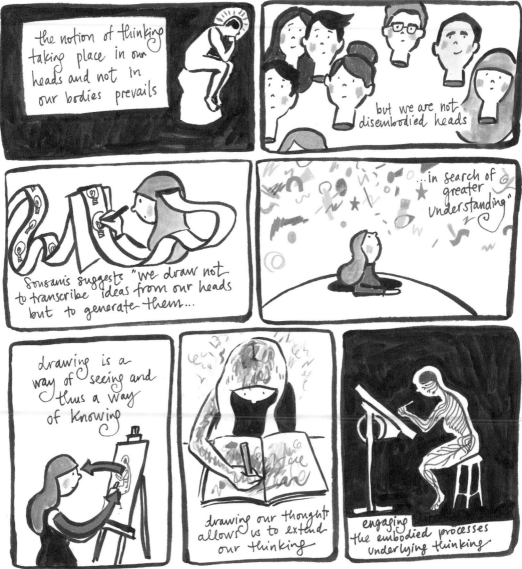

the notion of thinking taking place in our heads and not in our bodies prevails

but we are not disembodied heads

Sousanis suggests "we draw not to transcribe ideas from our heads but to generate them...

...in search of greater understanding"

drawing is a way of seeing and thus a way of knowing

drawing our thought allows us to extend our thinking

engaging the embodied processes underlying thinking

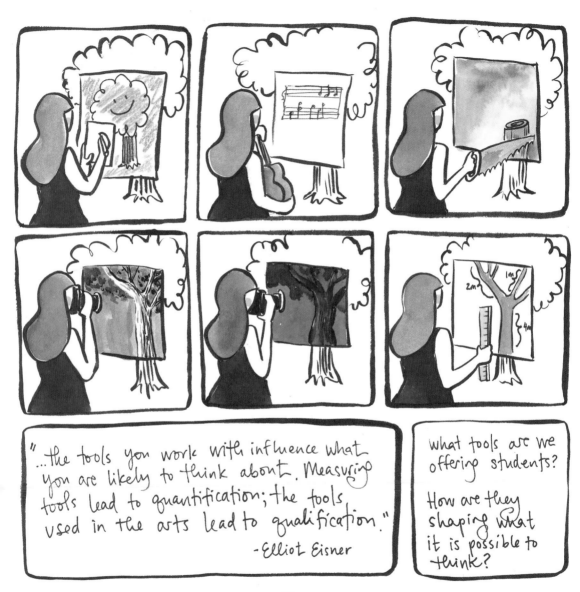

"...the tools you work with influence what you are likely to think about. Measuring tools lead to quantification; the tools used in the arts lead to qualification."
 -Elliot Eisner

What tools are we offering students?

How are they shaping what it is possible to think?

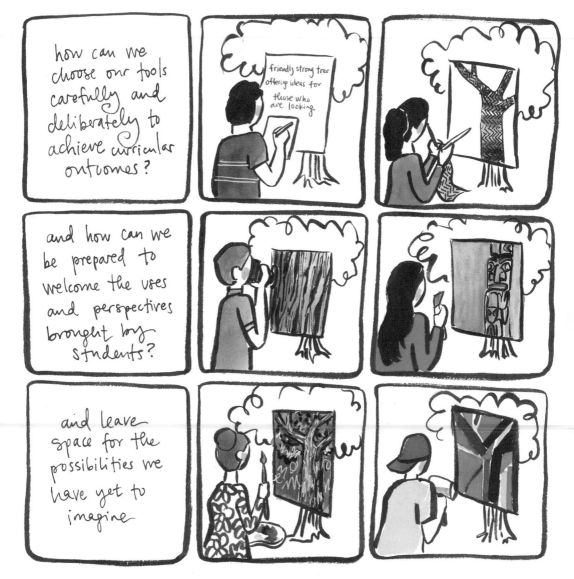

"we shape our tools...

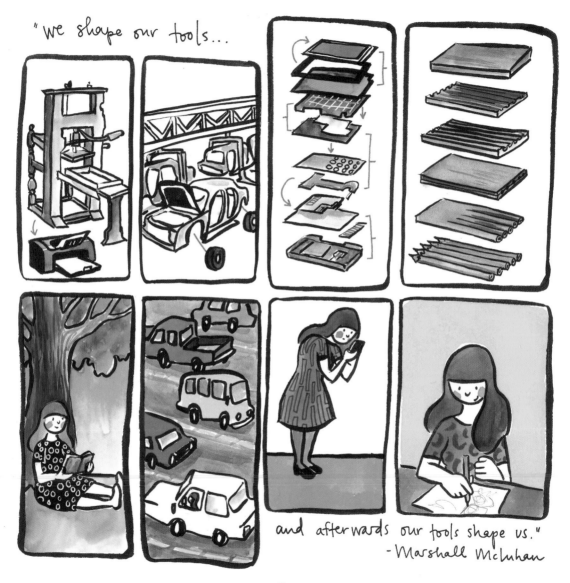

and afterwards our tools shape us."
— Marshall McLuhan

Laurel Richardson suggests in "Writing: a method of Inquiry" that writing is not just a "mopping-up activity at the end of a research project,"

instead,
Writing is a Way of Knowing

and Richardson asks:

How do we create texts that are vital?

That are attended to?

That make a difference?

Like Richardson, I draw write because I want to learn something I didn't know before I wrote it. drew

We associate the elements of an image with objects and emotions we have experienced in the real world;

elements such as scale, colour, texture and shape connect to remembered sensory experiences and can be used by image makers as a communicative tool. We can relate to the feeling of...

touching smooth or pointy objects

feeling fearful in a dark space

the beauty of a sunset

feeling small

the smell and warmth of a fire

the effects of gravity on an object

smooth, flat, horizontal shapes provide a sense of stability and calm

why is this important? Because images have the ability to influence our worldview and knowing HOW images can communicate meaning can help us read them critically and make them deliberately

vertical shapes are exciting and active

they give a sense of hopefulness and kinetic energy

diagonals are dynamic

they give a sense of movement

* adapted from Molly Bang's principles in her book *Picture This: How Pictures Work*

87

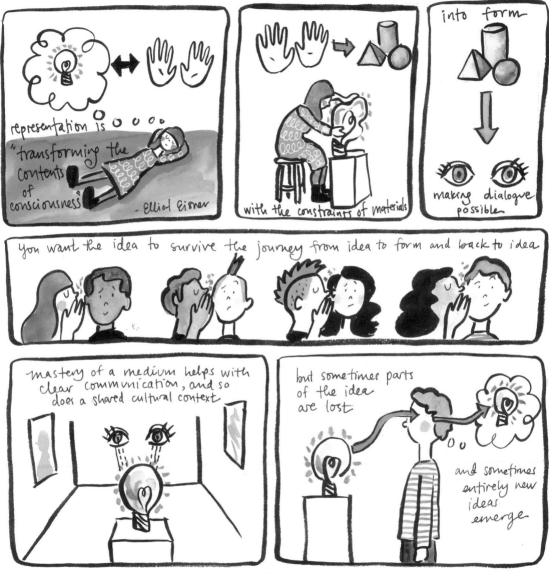

representation is "transforming the contents of consciousness"
— Elliot Eisner

with the constraints of materials

into form

making dialogue possible

you want the idea to survive the journey from idea to form and back to idea

mastery of a medium helps with clear communication, and so does a shared cultural context

but sometimes parts of the idea are lost

and sometimes entirely new ideas emerge

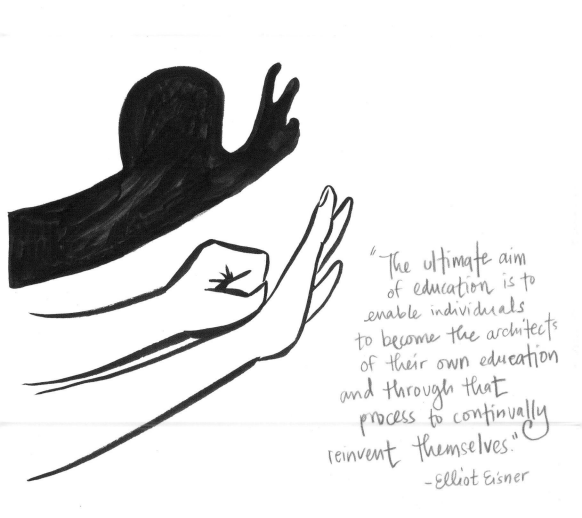

"The ultimate aim
of education is to
enable individuals
to become the architects
of their own education
and through that
process to continually
reinvent themselves."
-Elliot Eisner

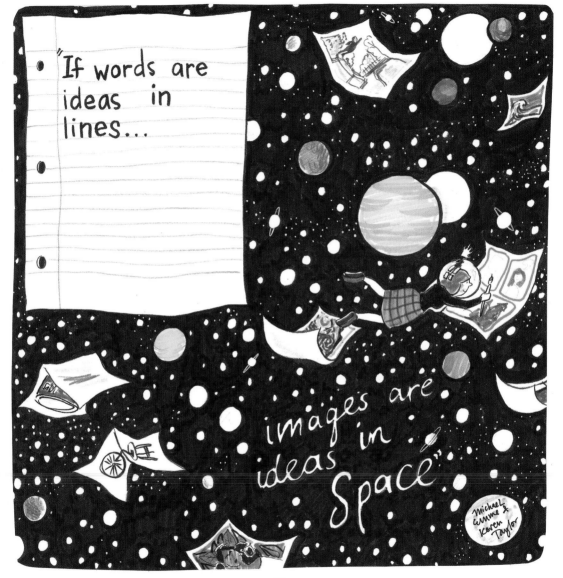

90

Texture

Texture is the element of art that refers to tactile qualities - the way things feel - engaging our sense of touch. The textures of life; personal, professional and otherwise, impact who we are and how we teach

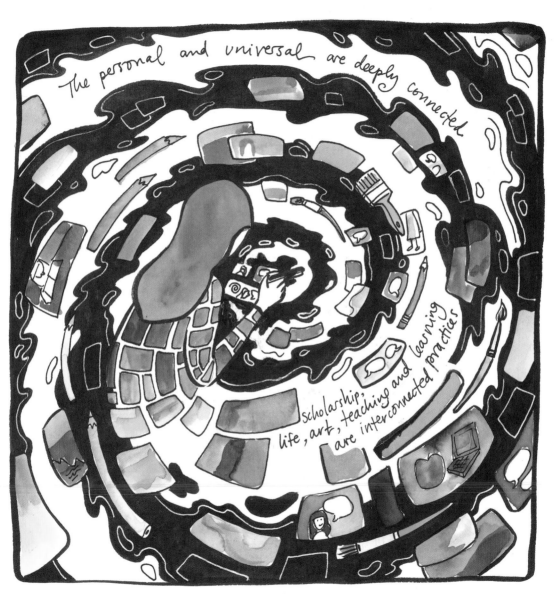

The personal and universal are deeply connected

Scholarship, life, art, teaching and learning are interconnected practices

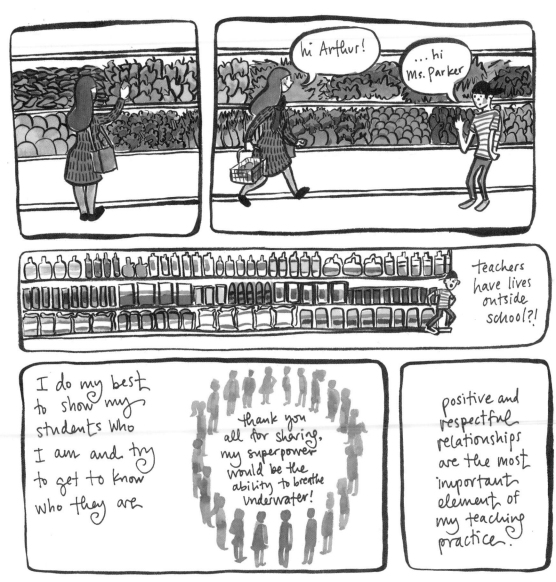

"The horizon of inquiry is our everydayness and our immediate participation in daily life"

Karen Meyer's pedagogy and practice of living Inquiry invites us to open up to "what is questionable in the world, to what normally goes unnoticed"

as well as "the newness, truth and beauty in daily life"

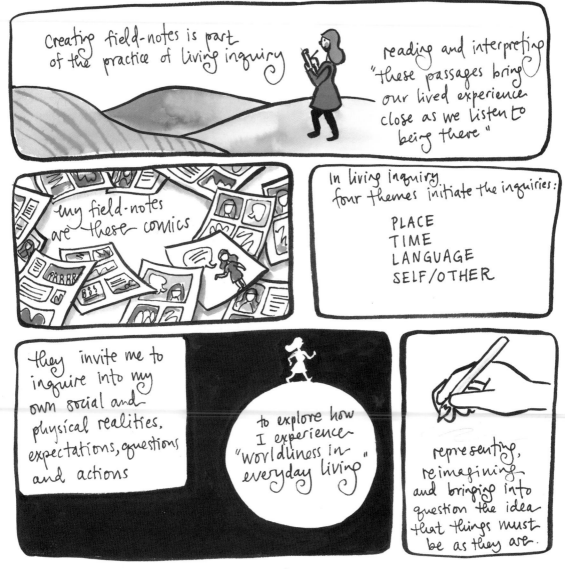

Creating field-notes is part of the practice of living inquiry

reading and interpreting "these passages bring our lived experience close as we listen to being there"

my field-notes are these comics

In living inquiry, four themes initiate the inquiries:

PLACE
TIME
LANGUAGE
SELF/OTHER

they invite me to inquire into my own social and physical realities, expectations, questions and actions

to explore how I experience "worldliness in everyday living"

representing, reimagining and bringing into question the idea that things must be as they are.

97

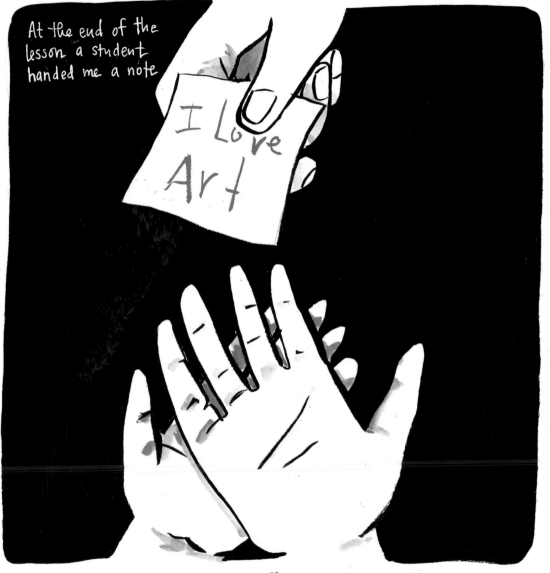

TIME

Each moment is influenced
by our past, present and future.
How are experiences
shaped by time?

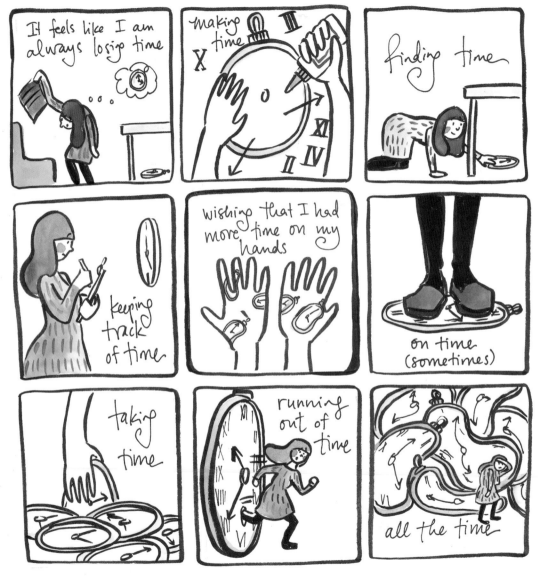

101

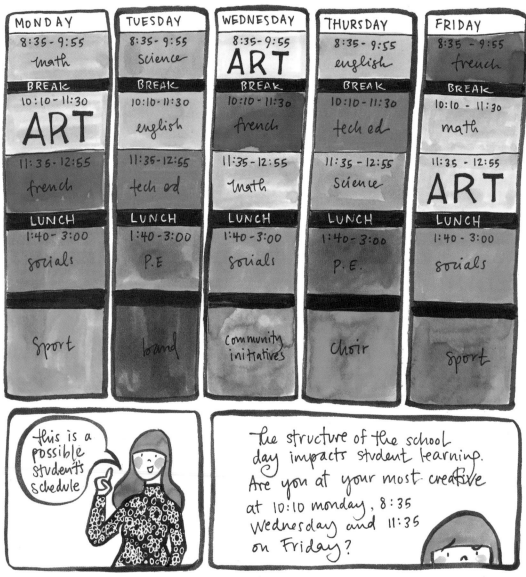

102

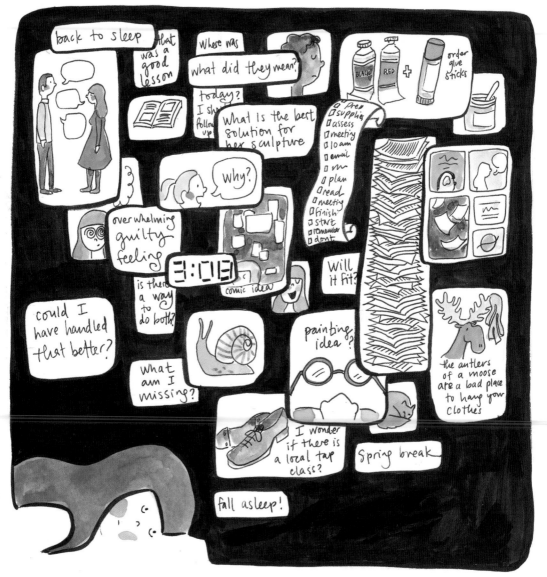

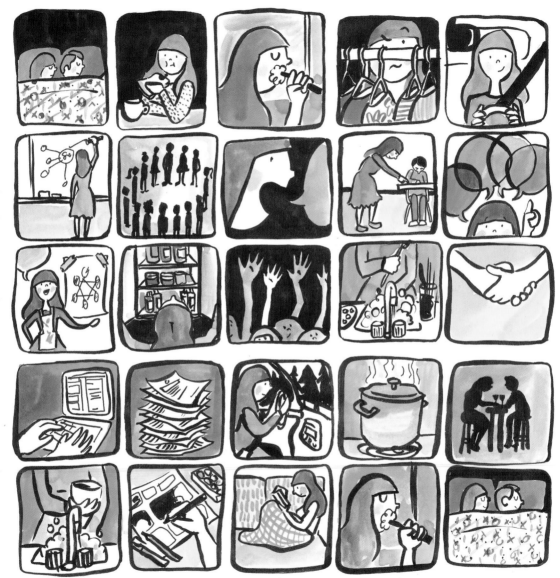

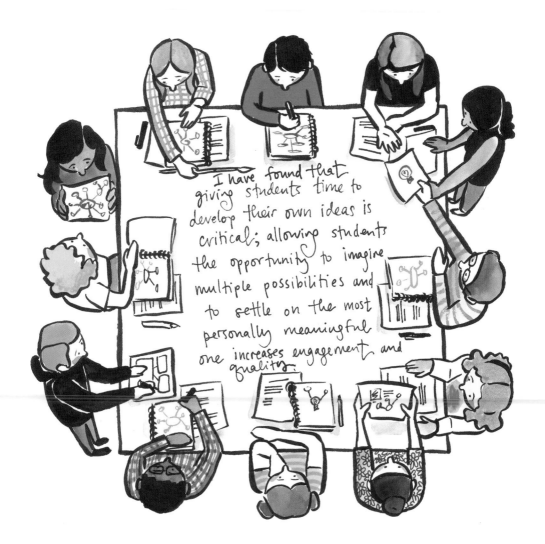

I have found that giving students time to develop their own ideas is critical; allowing students the opportunity to imagine multiple possibilities and to settle on the most personally meaningful one increases engagement and quality.

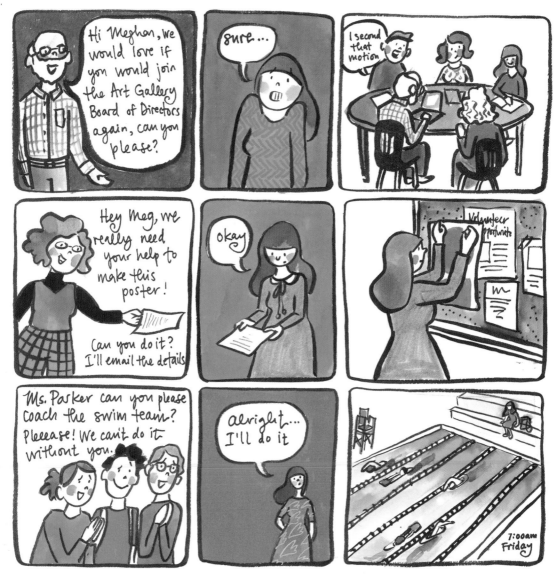

106

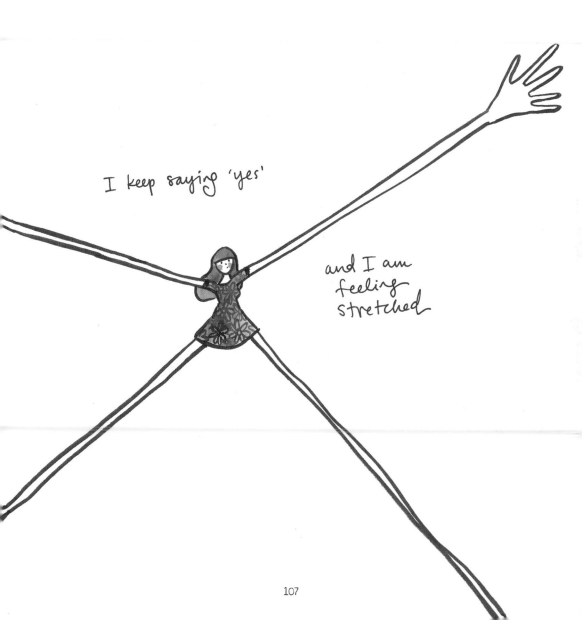

to do

- [] prepare student work for public display
- [] unload and store the shipment of clay
- [] create a classroom that's inviting
- [] strengthen academic and creative writing
- [] cross-curricular connections, make learning relevant
- [] make use of resources, professional development
- [] ultimate coaching, We schools club
- [] field trip Friday, prepare for the sub
- [] meaningfully integrate indigenous perspectives
- [] make Art the most popular of all the electives
- [] provide the right scaffolding - don't keep them guessin'
- [] differentiate instruction within every lesson
- [] artfully deliver every presentation
- [] push back against the pressures of standardization

- [] photocopies, exemplars, MyEd BC
- [] coursework for your masters degree
- [] go to staff committee meetings
- [] cherish all the friendly greetings
- [] parent communication, core competencies
- [] be holistic, student-centered, know the IEPs

☐ provide meaningful feedback, techniques and tips
☐ reminders, forms, walking field trips
☐ big Ideas guiding your unit
☐ formative assessment so you know how to tune it
☐ critical thinking, social justice connections
☐ trick them into writing reflections
☐ teach Canadian Art and visual notetaking
☐ place the focus on the process of making
☐ develop your art practice and share your talents
☐ exercise, socialize, work-life balance
☐ be humble, be gentle, prepare to be wrong
☐ I better get working, this list is too long

I am sure that there is something that I've missed,

and for my own self-assessment based on this list

despite my productive inclinations,

I am struggling to meet my own expectations

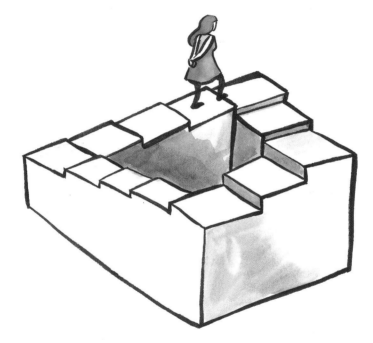

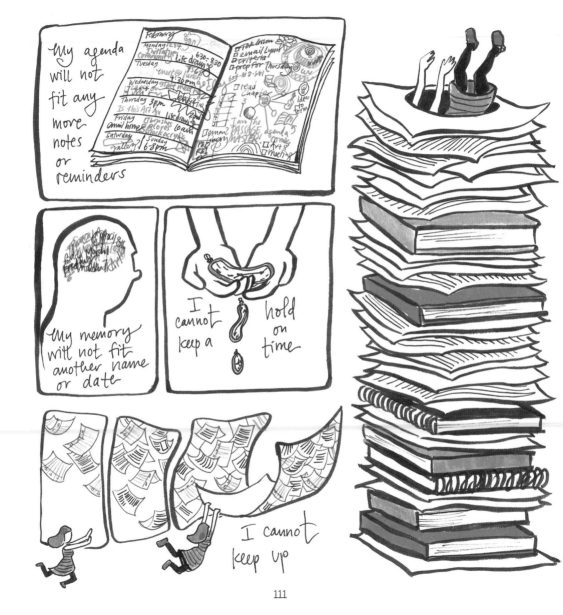

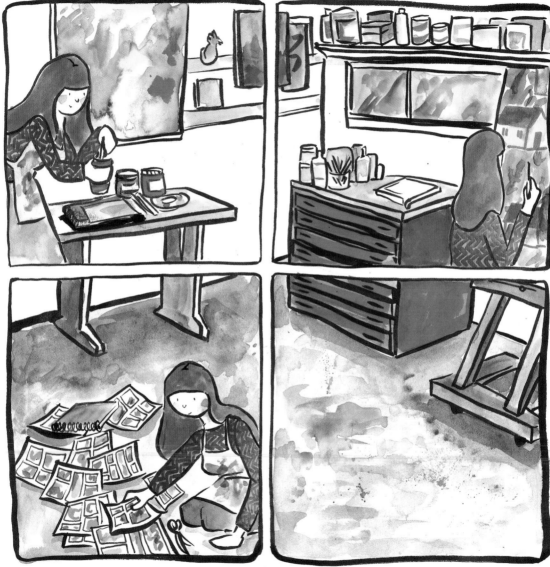

LANGUAGE

languages encompass many mediums through which we communicate, interpret and think. How are our worldviews both shaping and being shaped by the languages we use?

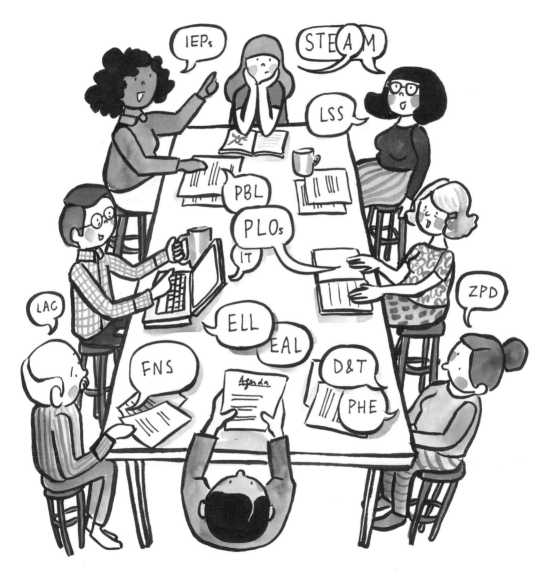

Sometimes all in a single day I feel...

 amused

 angry

 curious

 patient

 suspicious

 delighted

 proud

 confused

 disappointed

 cheeky

 embarrassed

 frustrated

 sad

 surprised

 desperate

 tired

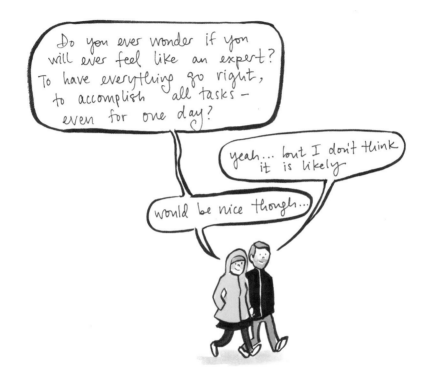

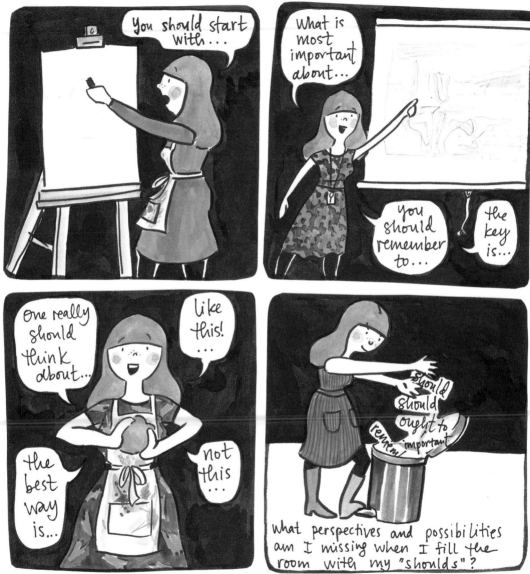

117

SELF/OTHER

attending to relationships, connections, dynamics and identities

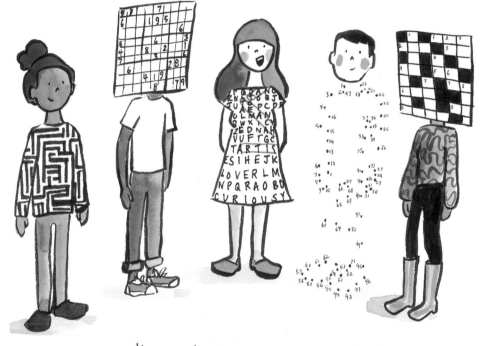

we are all puzzles trying to figure each other out and trying to understand another person is a worthwhile thing to do.

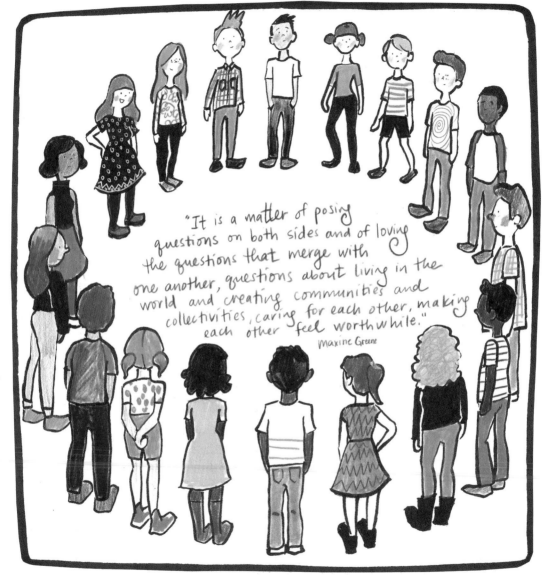

"It is a matter of posing questions on both sides and of loving the questions that merge with one another, questions about living in the world and creating communities and collectivities, caring for each other, making each other feel worthwhile."

Maxine Greene

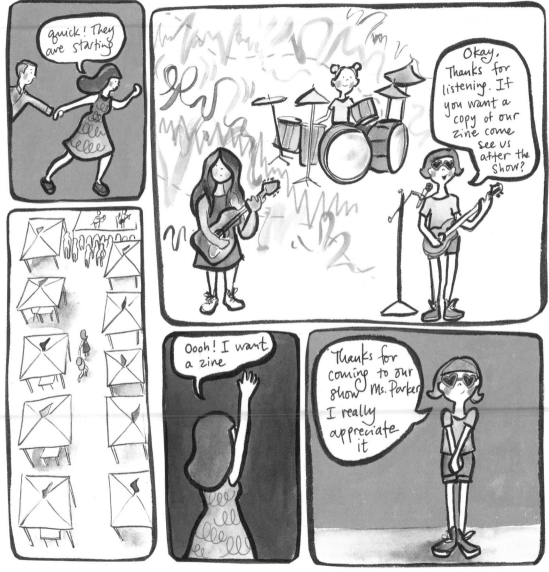

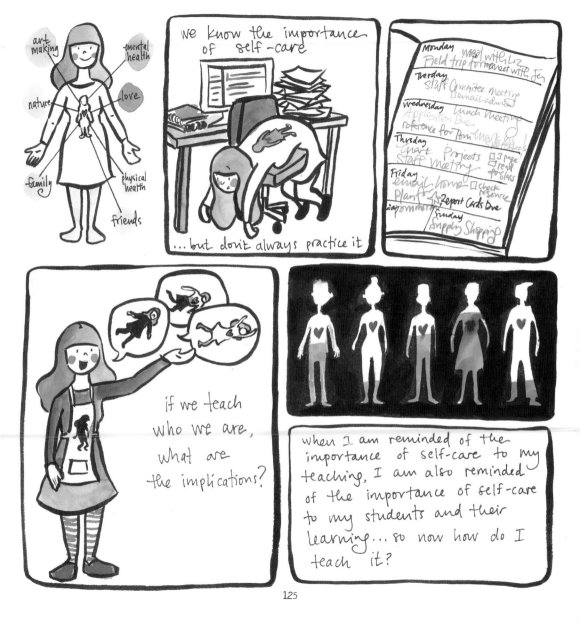

125

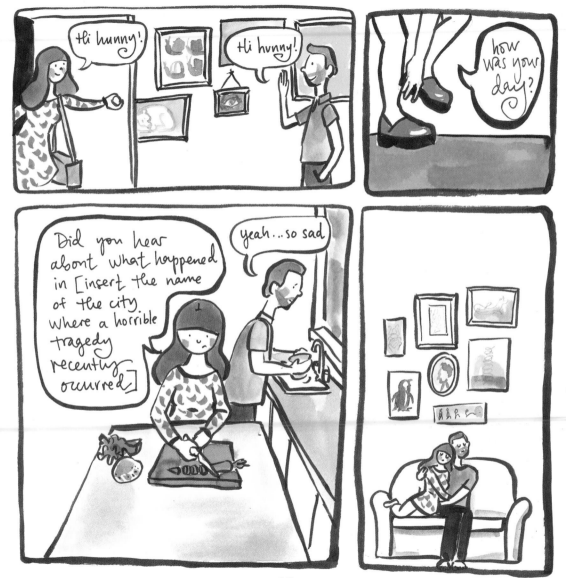

" ... works of art may radiate
through our variously lived worlds,
exposing the darks and the lights,
the wounds and the scars and the healed
places, the empty containers and the
overflowing ones, the faces ordinarily
lost in the crowds. "
 —Maxine Greene

some days
the world is too noisy
some days

some days there is a heaviness, a darkness, connections missed, communications confused,

uncertainty

loneliness

hopelessness

self-doubt

some days it feels as though there may never be a solution to the challenges faced in our education system and beyond

some days, you want to hide

and it is on those days that we need art the most

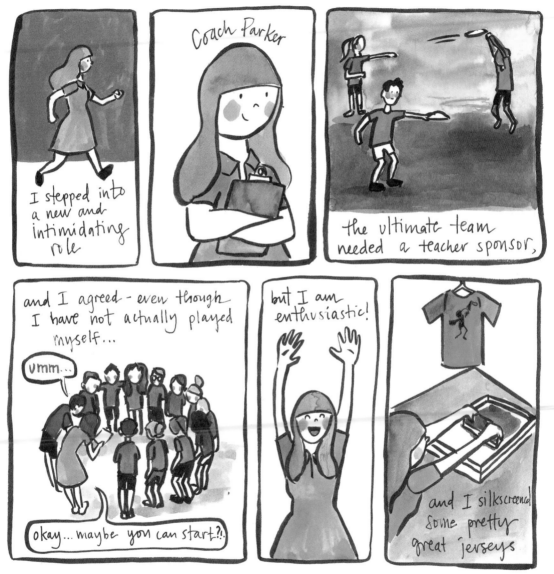

I stepped into a new and intimidating role

Coach Parker

the ultimate team needed a teacher sponsor,

and I agreed - even though I have not actually played myself...

umm...

okay... maybe you can start?!!

but I am enthusiastic!

and I silkscreened some pretty great jerseys

PLACE

The "physical and social textures" of the places we inhabit, pass through, create and are shaped by.

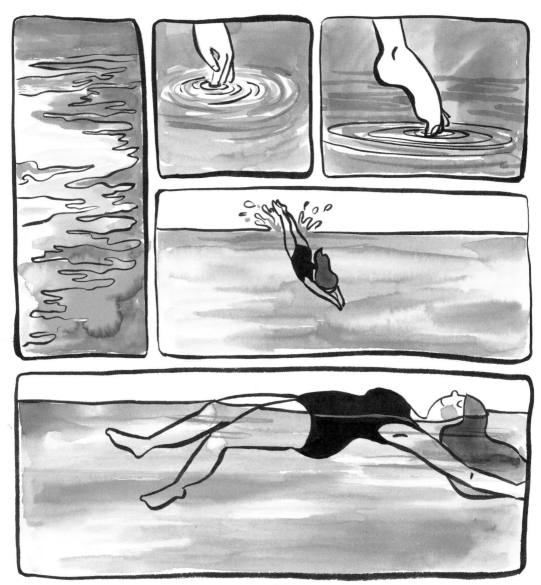

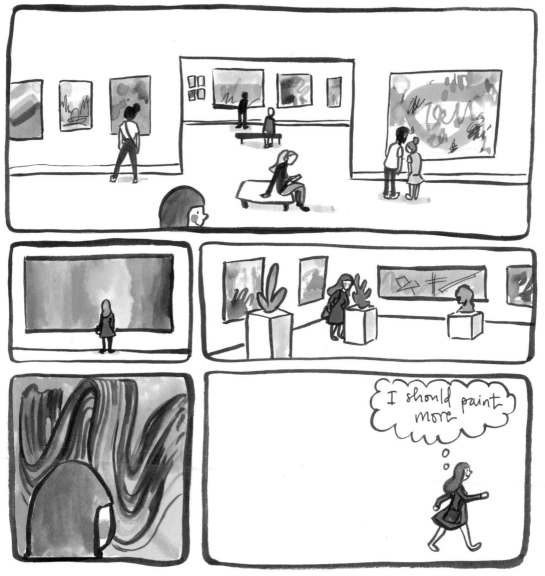

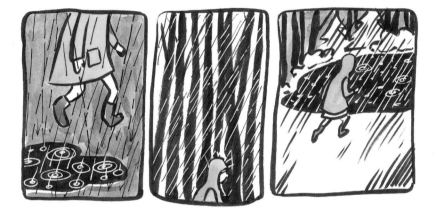

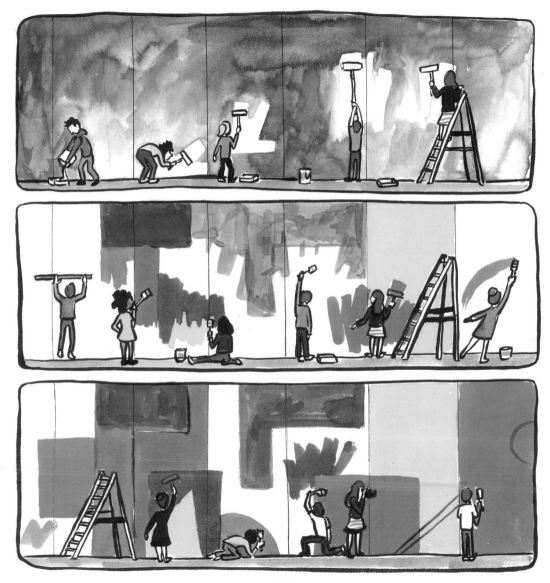

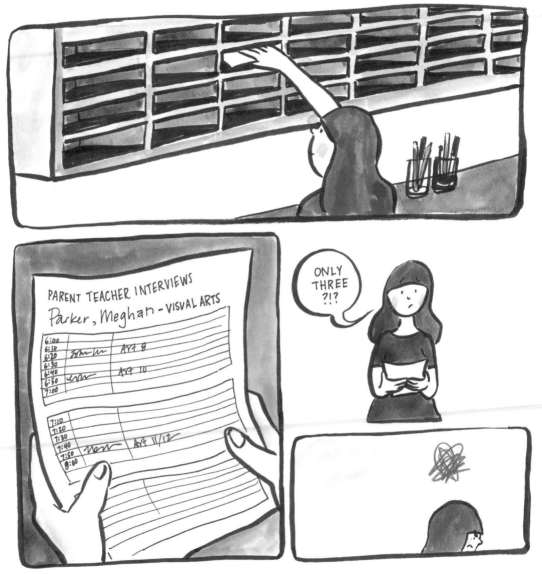

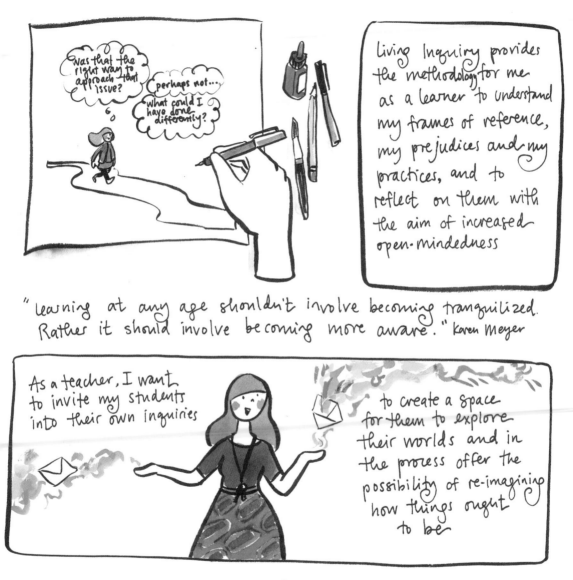

Living Inquiry provides the methodology for me as a learner to understand my frames of reference, my prejudices and my practices, and to reflect on them with the aim of increased open-mindedness

"Learning at any age shouldn't involve becoming tranquilized. Rather it should involve becoming more aware." Karen Meyer

Shape

Shape is the element of art referring to enclosed spaces with boundaries, making up geometric and organic shapes. While learning takes place within and without boundaries the way we shape experiences in the classroom and beyond defines many opportunities for teaching and learning.

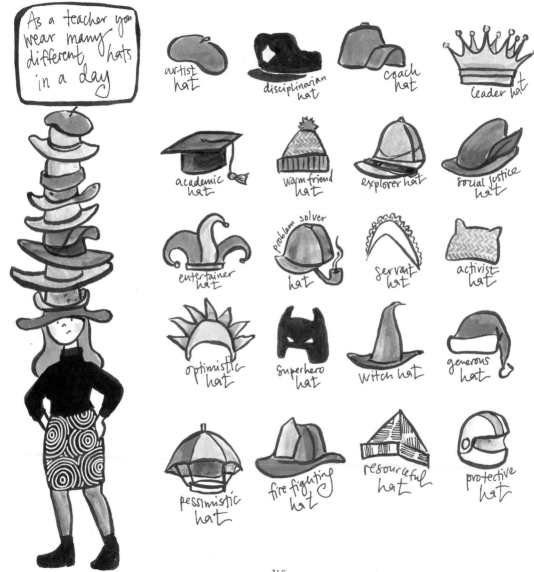

As a teacher you wear many different hats in a day

artist hat

disciplinarian hat

coach hat

leader hat

academic hat

warm friend hat

explorer hat

social justice hat

entertainer hat

problem solver hat

servant hat

activist hat

optimistic hat

superhero hat

witch hat

generous hat

pessimistic hat

fire fighting hat

resourceful hat

protective hat

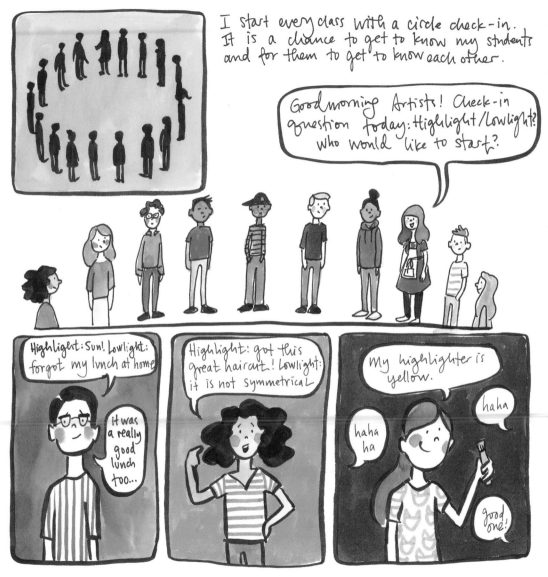

149

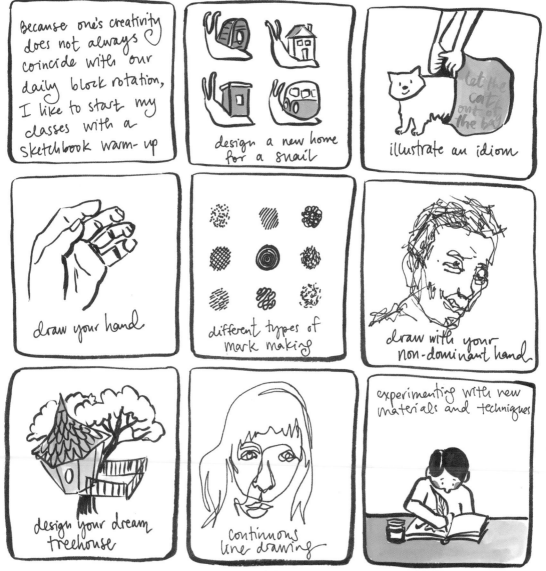

Because one's creativity does not always coincide with our daily block rotation, I like to start my classes with a sketchbook warm-up

design a new home for a snail

illustrate an idiom

draw your hand

different types of mark making

draw with your non-dominant hand

design your dream treehouse

continuous line drawing

experimenting with new materials and techniques

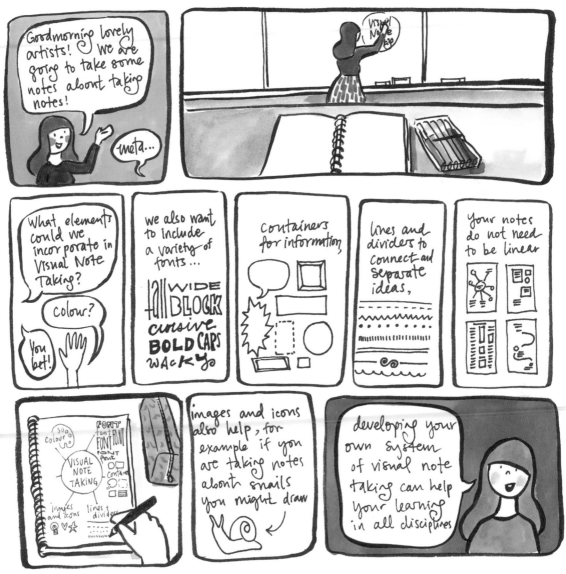

151

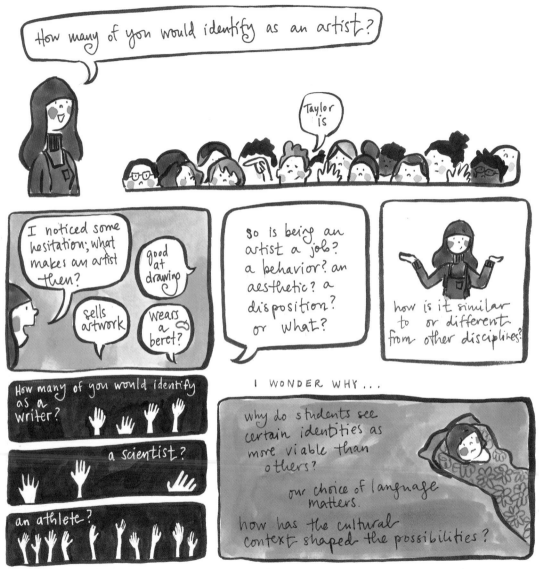

152

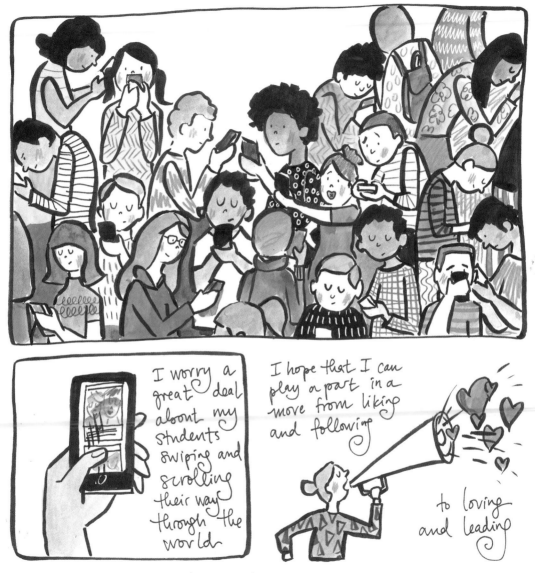

I worry a great deal about my students swiping and scrolling their way through the world

I hope that I can play a part in a move from liking and following

to loving and leading

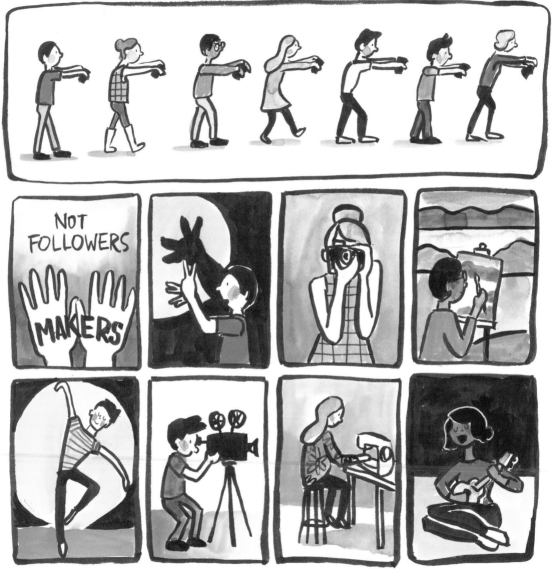

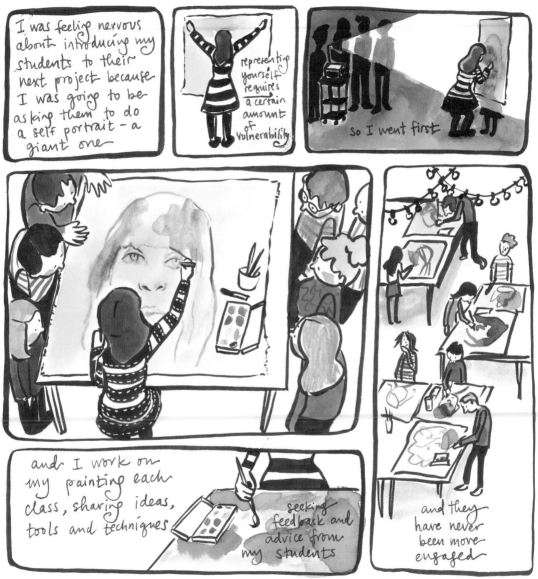

I was feeling nervous about introducing my students to their next project because I was going to be asking them to do a self portrait - a giant one

representing yourself requires a certain amount of vulnerability

So I went first

and I work on my painting each class, sharing ideas, tools and techniques

seeking feedback and advice from my students

and they have never been more engaged

155

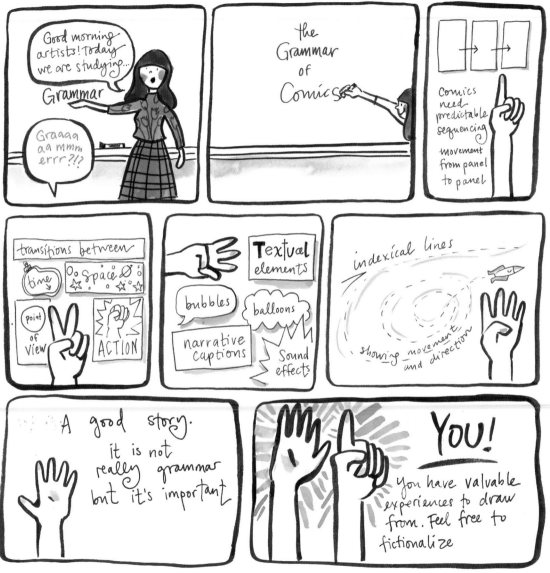

157

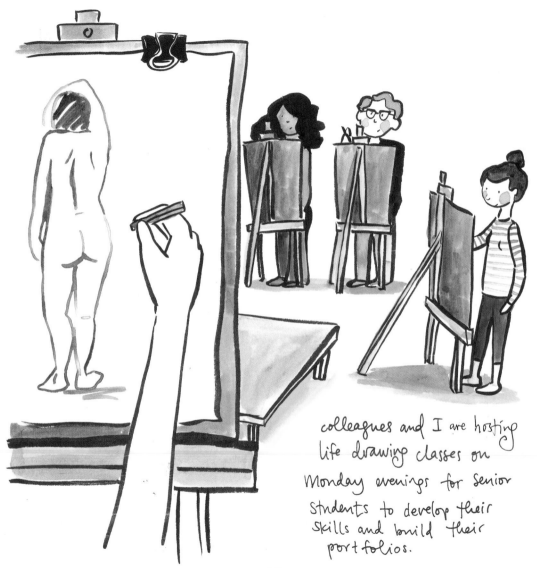

colleagues and I are hosting life drawing classes on Monday evenings for senior students to develop their skills and build their portfolios.

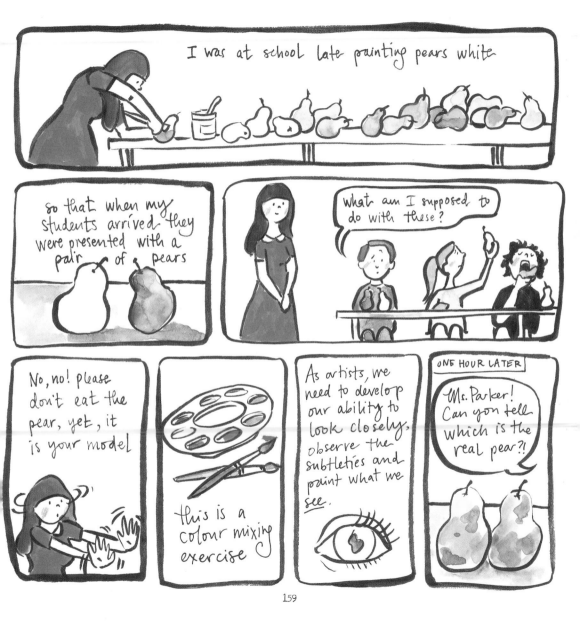

I had an idea to get students thinking about what they already know about visual communication

With 30 minutes, paper, scissors and glue, students were asked to translate concepts visually

after a quick demo they got started

lonely structured
chaotic tension

lonely structured
chaotic tension

lonely structured
chaotic tension

lonely structured
chaotic tension

I was blown away. Students were able to wordlessly express complex concepts in their own unique and diverse ways.

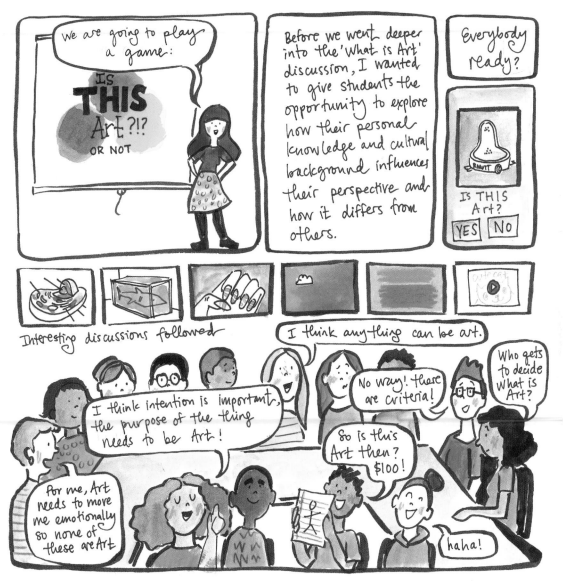

161

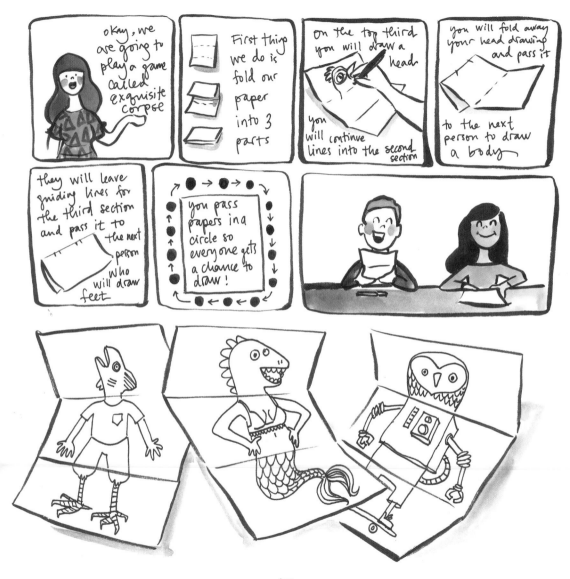

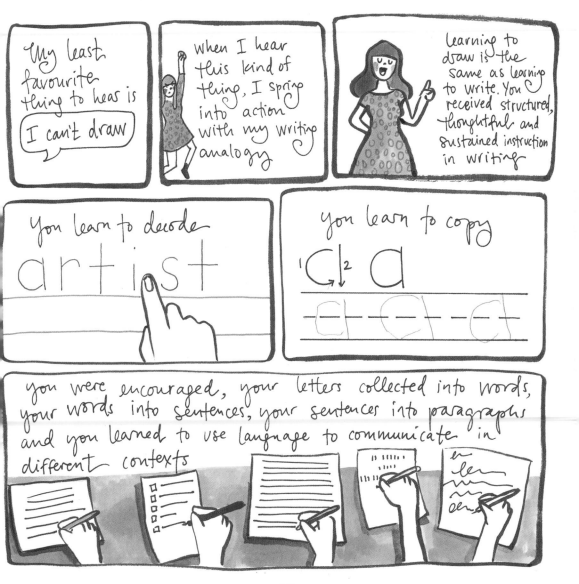

Visual art is a language in the same way text is - the elements of art are its alphabet

You learn to decode

You learn to copy

You practice, practice, practice and eventually your separate elements combine creating more complex imagery

We do not expect students to write a sonnet before they know the alphabet

What could be communicated if we taught drawing in the same way we do writing?

What knowledge are we missing?

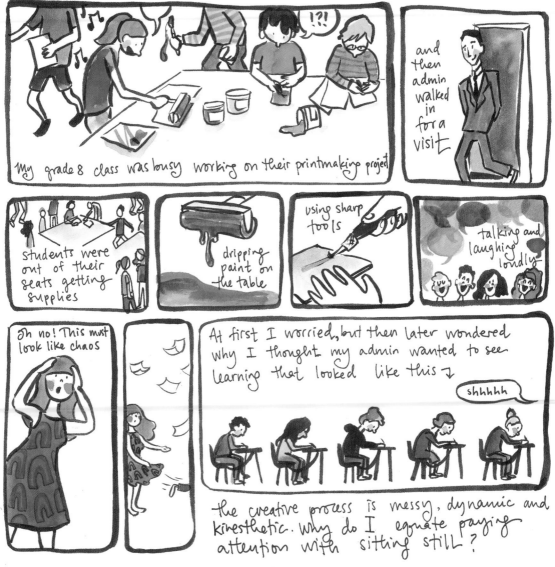

My grade 8 class was busy working on their printmaking project

and then admin walked in for a visit

!?!

students were out of their seats getting supplies

dripping paint on the table

using sharp tools

talking and laughing loudly

Oh no! This must look like chaos

At first I worried, but then later wondered why I thought my admin wanted to see learning that looked like this

shhhhh

the creative process is messy, dynamic and kinesthetic. why do I equate paying attention with sitting still?

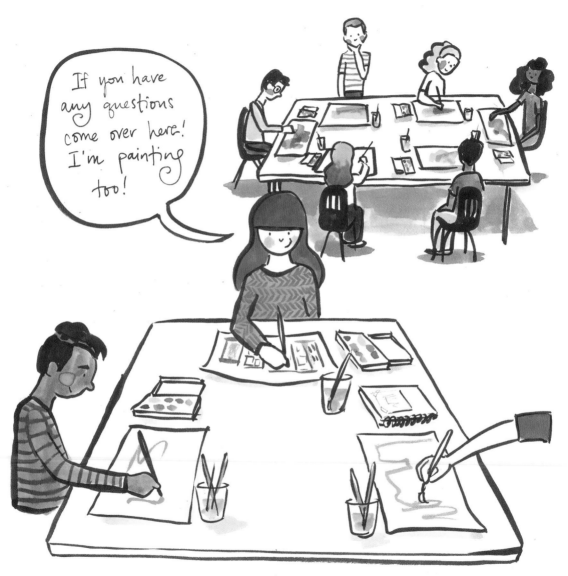

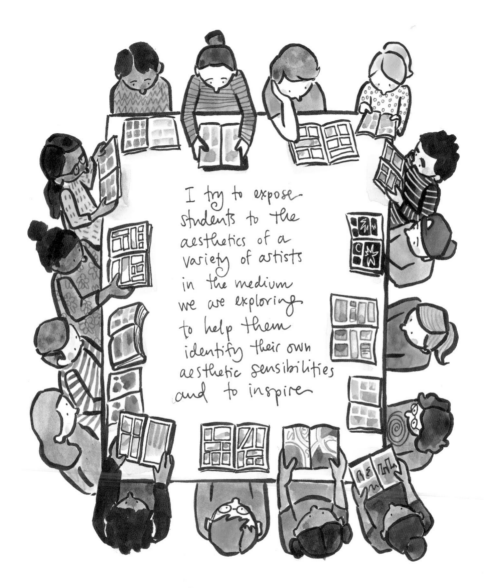

I try to expose
students to the
aesthetics of a
variety of artists
in the medium
we are exploring
to help them
identify their own
aesthetic sensibilities
and to inspire

field trip forms

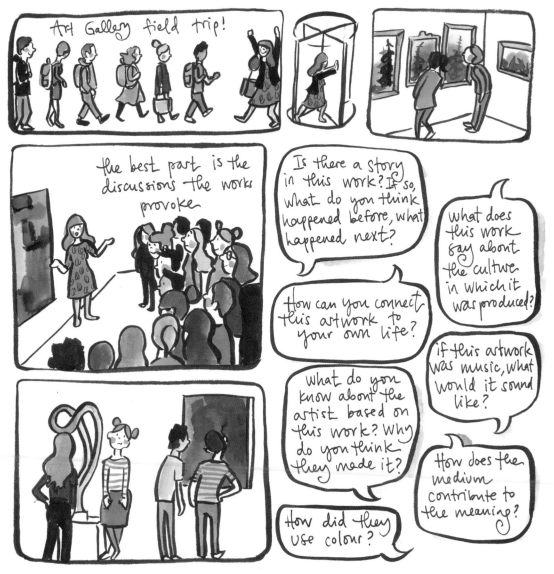

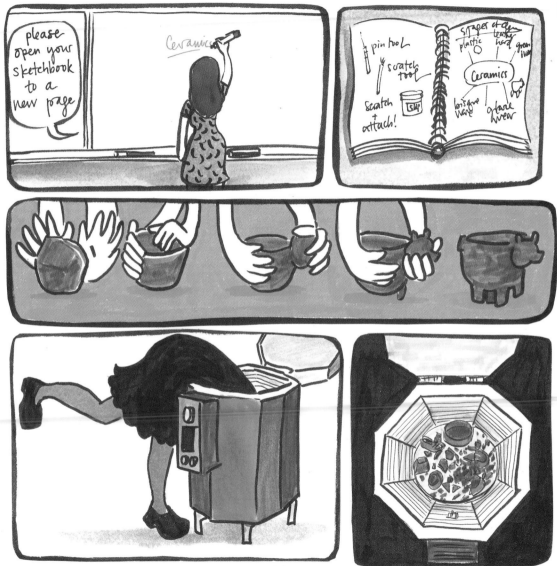

171

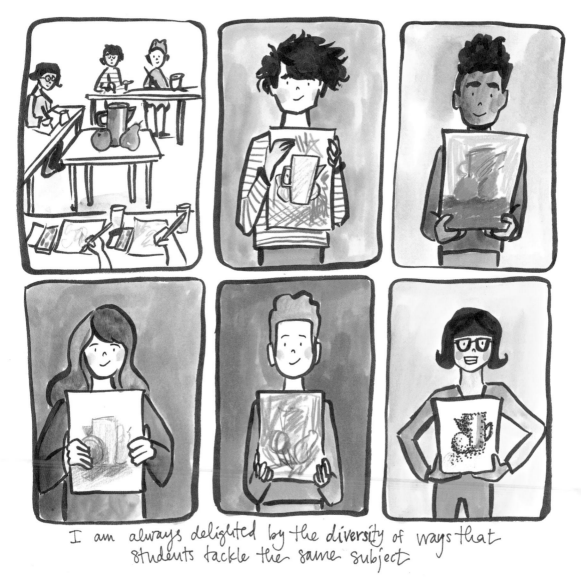

I am always delighted by the diversity of ways that students tackle the same subject

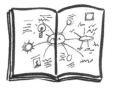

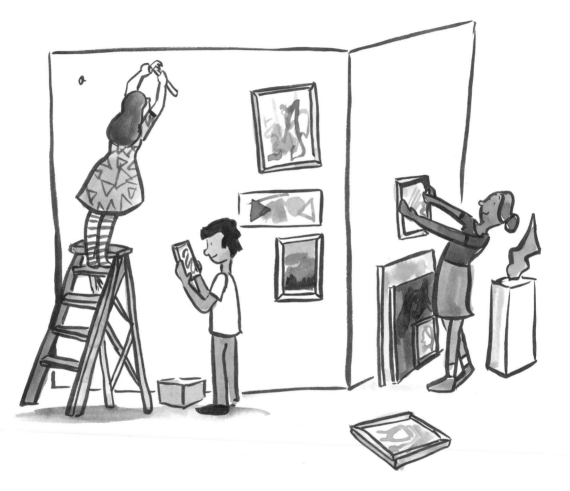

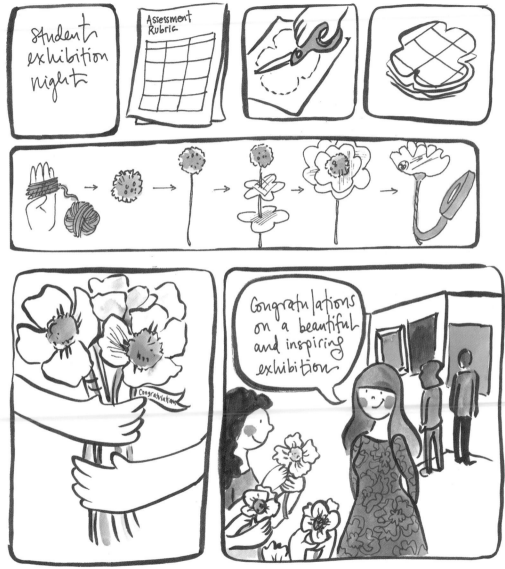

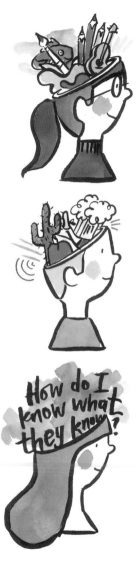

How do I know what they know?

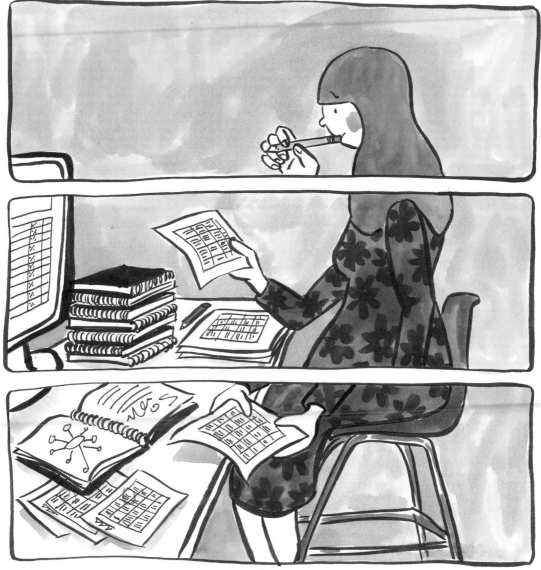

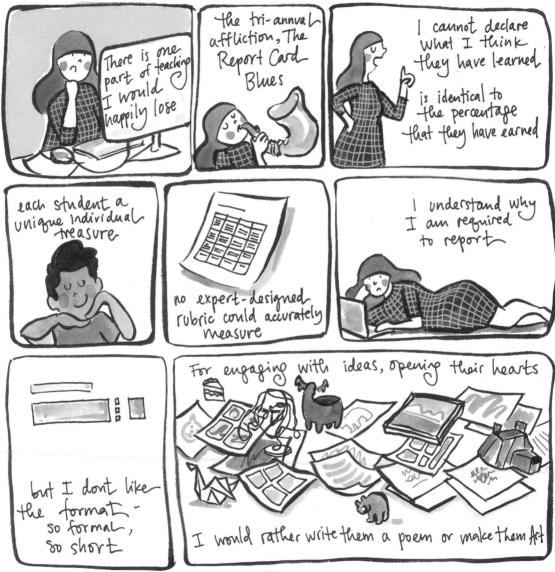

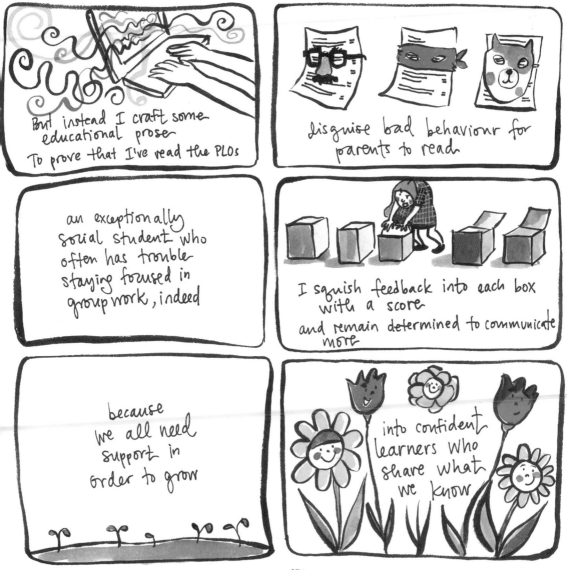

But instead I craft some educational prose
To prove that I've read the PLOs

disguise bad behaviour for parents to read

an exceptionally social student who often has trouble staying focused in group work, indeed

I squish feedback into each box with a score
and remain determined to communicate more

because we all need support in order to grow

into confident learners who share what we know

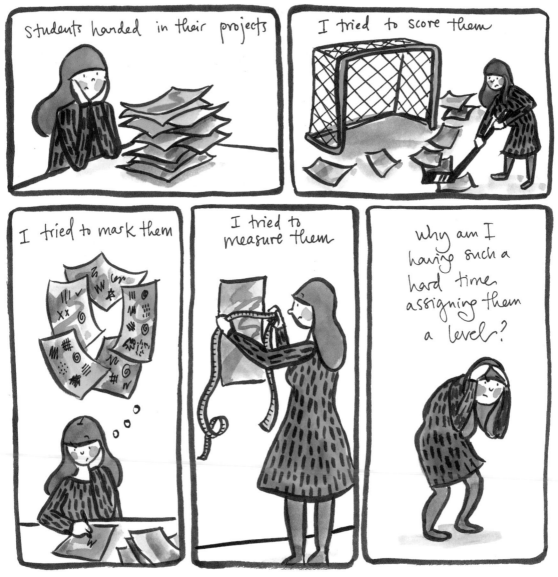

Space

Space is the element of art that refers to a sense of depth, as well as positive and negative space. What kinds of spaces are we creating in schools? How can we create welcoming learning spaces for students? How can we make space for ideas and possibilities?

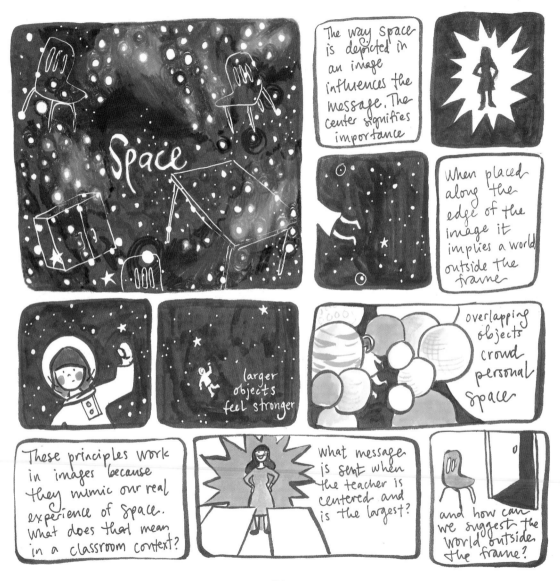

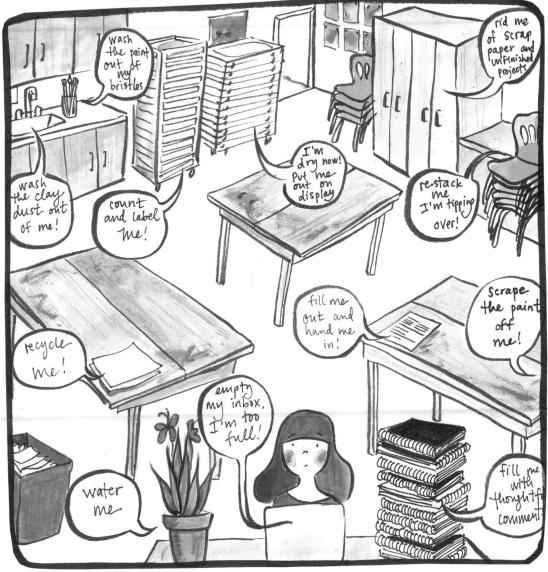

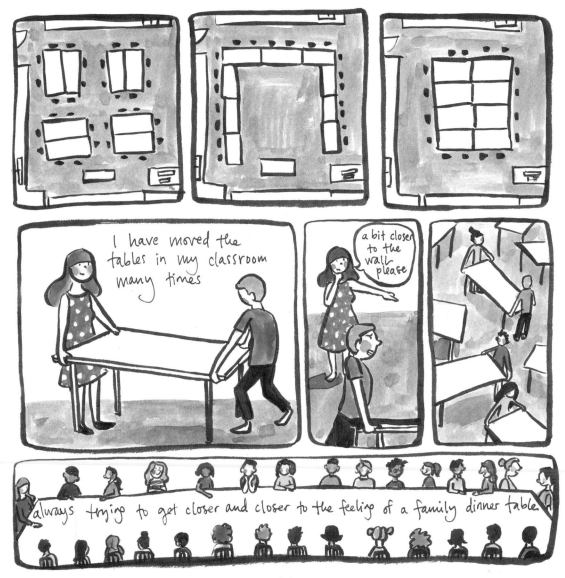

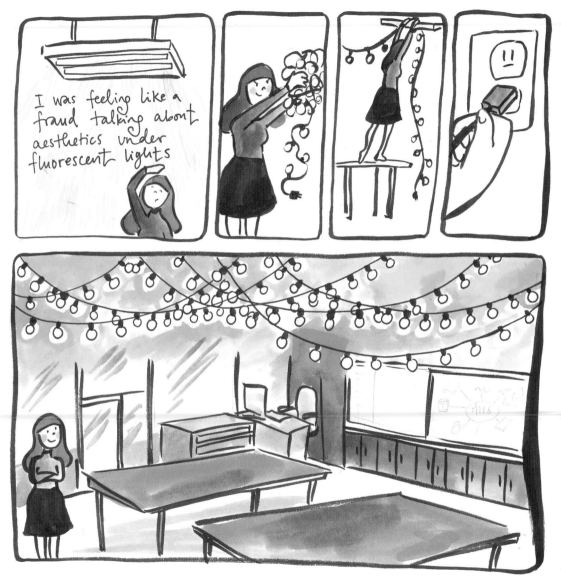

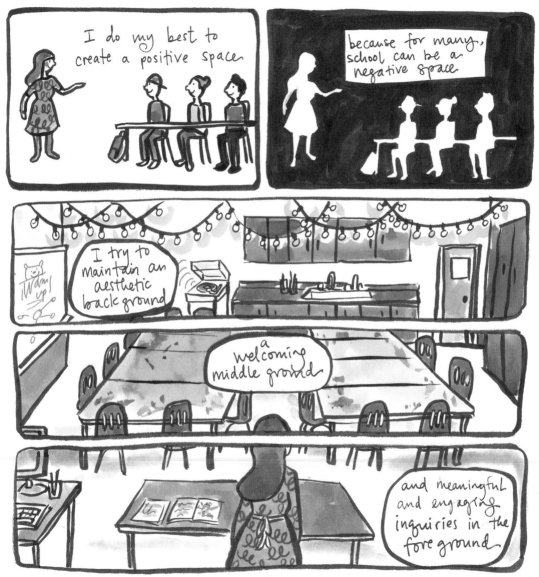

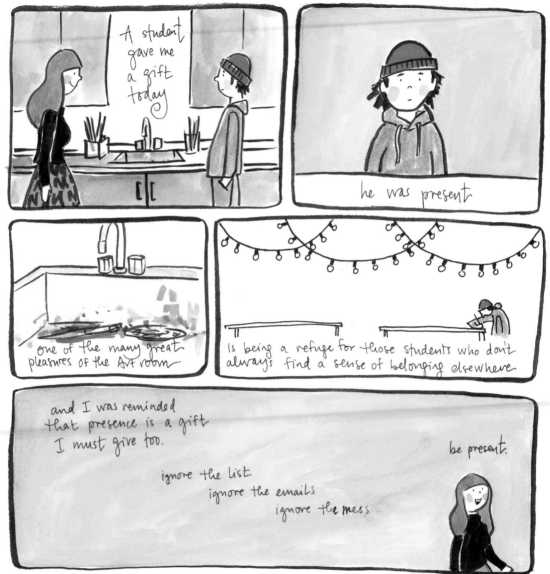

A student gave me a gift today

he was present

one of the many great pleasures of the Art room

is being a refuge for those students who don't always find a sense of belonging elsewhere

and I was reminded that presence is a gift I must give too.

ignore the list
ignore the emails
ignore the mess

be present.

"The studio is a space and a condition wherein creative play and progressive thinking yield propositions for reflecting on who we are - individually and collectively - and where we might go next."

"To truly liberate the imagination is to have the space and freedom to reflect, critique, and innovate, key processes for introducing change and advancing democratic ideals."
—Lisa Wainwright

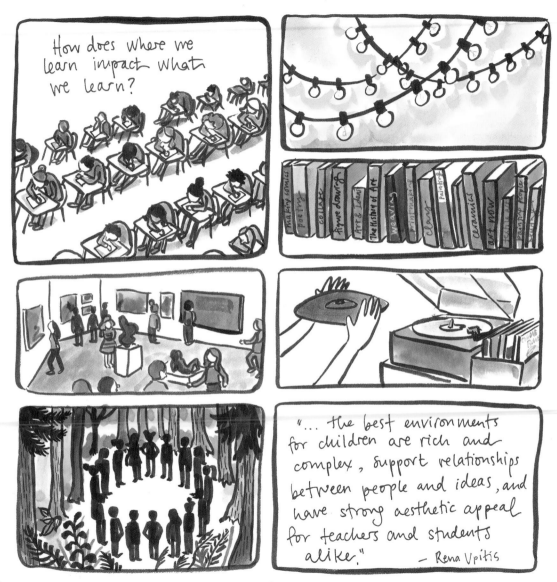

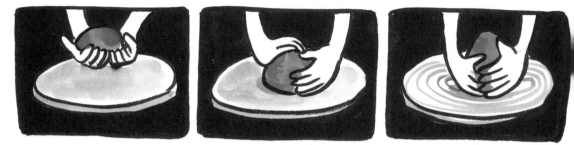

In the studio knowledge is kneaded - materially and conceptually "through the push-and-pull of a medium - be it physical, digital, language-based, or otherwise [it] empowers the learner."

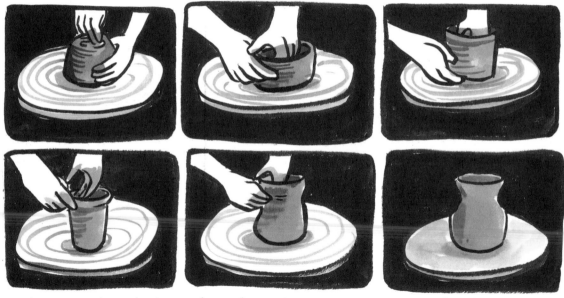

" ... creative testing through making remains essential to knowing"

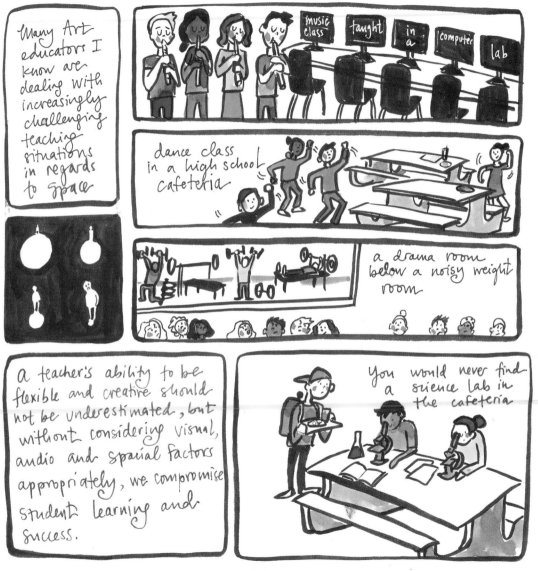

Many Art educators I know are dealing with increasingly challenging teaching situations in regards to space

music class taught in a computer lab

dance class in a high school cafeteria

a drama room below a noisy weight room

a teacher's ability to be flexible and creative should not be underestimated, but without considering visual, audio and spatial factors appropriately, we compromise student learning and success.

You would never find a science lab in the cafeteria

195

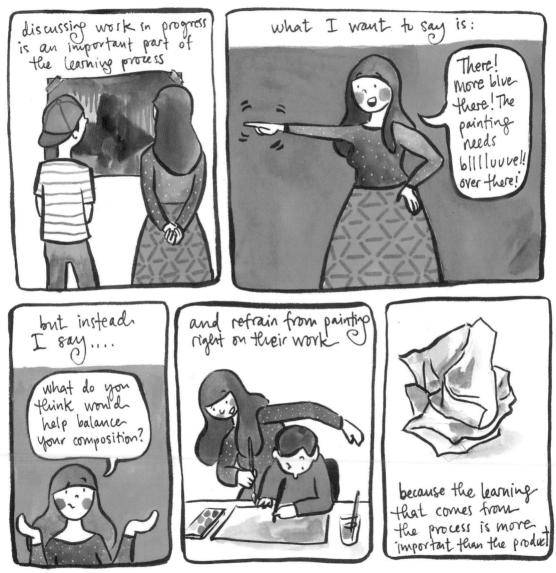

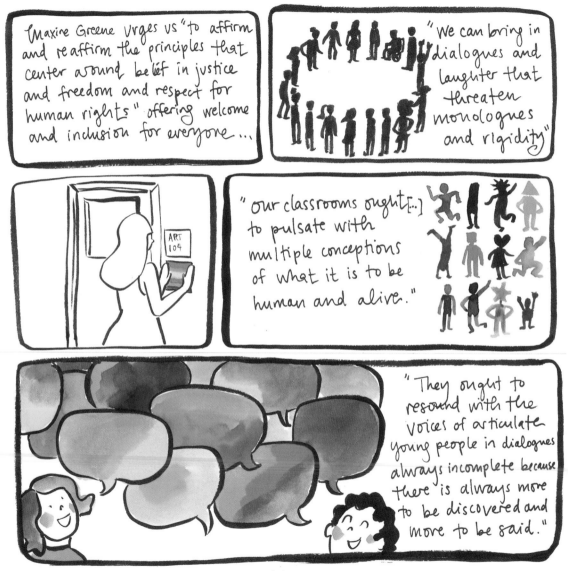

Maxine Greene urges us "to affirm and reaffirm the principles that center around belief in justice and freedom and respect for human rights" offering welcome and inclusion for everyone...

"We can bring in dialogues and laughter that threaten monologues and rigidity"

ART 104

"Our classrooms ought [...] to pulsate with multiple conceptions of what it is to be human and alive."

"They ought to resound with the voices of articulate young people in dialogues always incomplete because there is always more to be discovered and more to be said."

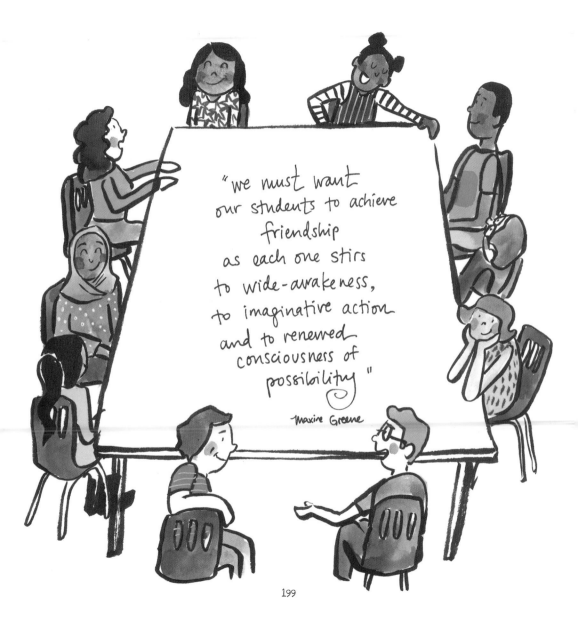

"we must want
our students to achieve
friendship
as each one stirs
to wide-awakeness,
to imaginative action
and to renewed
consciousness of
possibility "

Maxine Greene

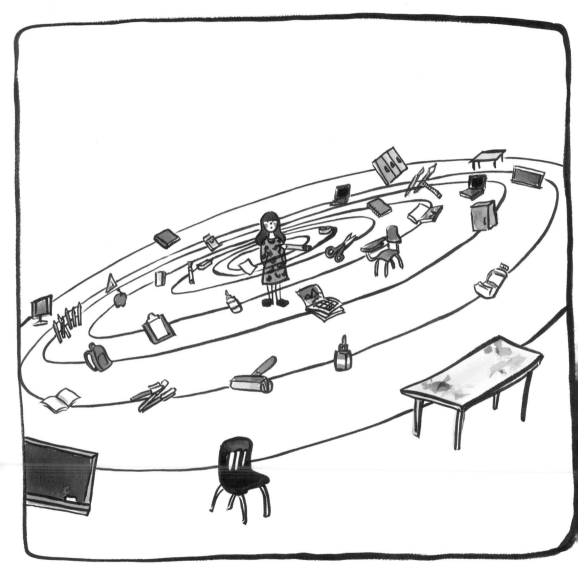

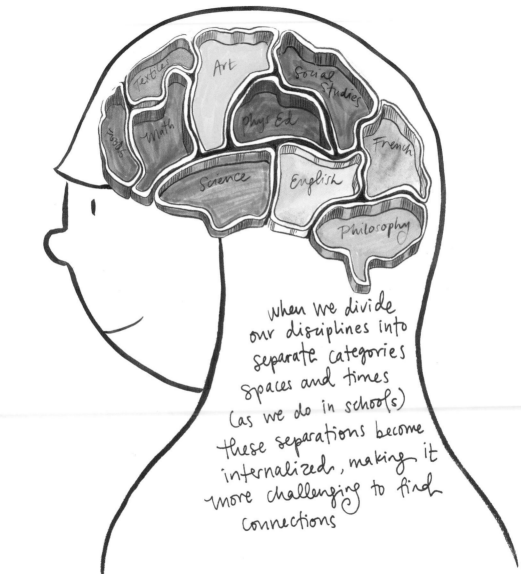

when we divide
our disciplines into
separate categories
spaces and times
(as we do in school(s)
these separations become
internalized, making it
more challenging to find
connections

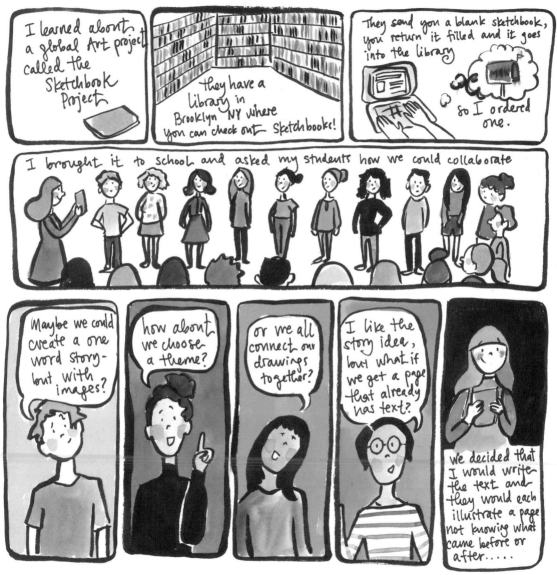

This is what I wrote and it is still in process

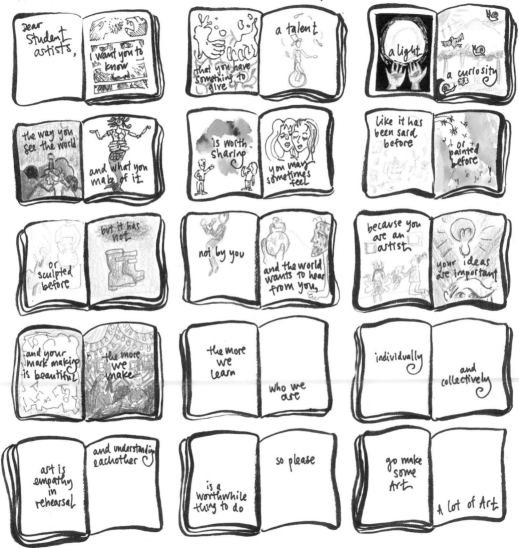

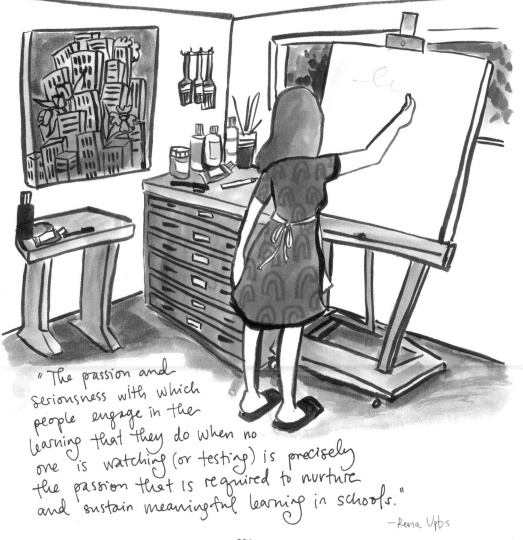

"The passion and seriousness with which people engage in the learning that they do when no one is watching (or testing) is precisely the passion that is required to nurture and sustain meaningful learning in schools."

—Rena Upbs

Value

Value is the element of art that
deals with the lightness or darkness of
tones or colours. As we deal with the
lightness and darkness of our own
lived experiences, what values
can the Arts teach us?

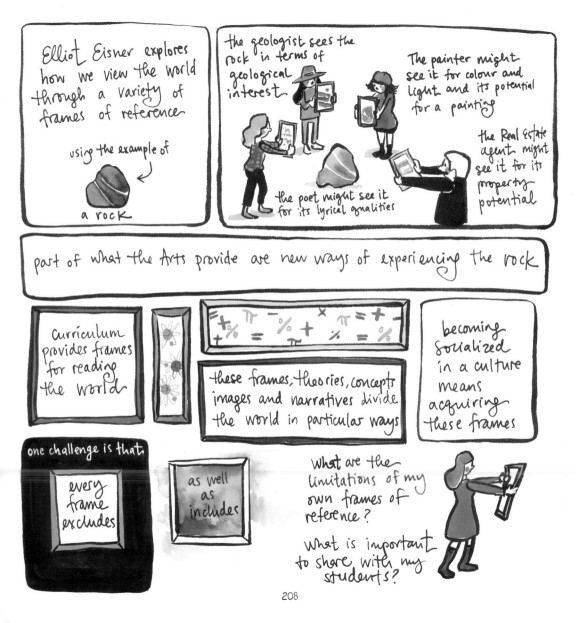

Elliot Eisner explores how we view the world through a variety of frames of reference

using the example of

→ a rock

the geologist sees the rock in terms of geological interest

The painter might see it for colour and light and its potential for a painting

the poet might see it for its lyrical qualities

the Real estate agent might see it for its property potential

part of what the Arts provide are new ways of experiencing the rock

curriculum provides frames for reading the world

these frames, theories, concepts images and narratives divide the world in particular ways

becoming socialized in a culture means acquiring these frames

one challenge is that

every frame excludes

as well as includes

what are the limitations of my own frames of reference?

what is important to share with my students?

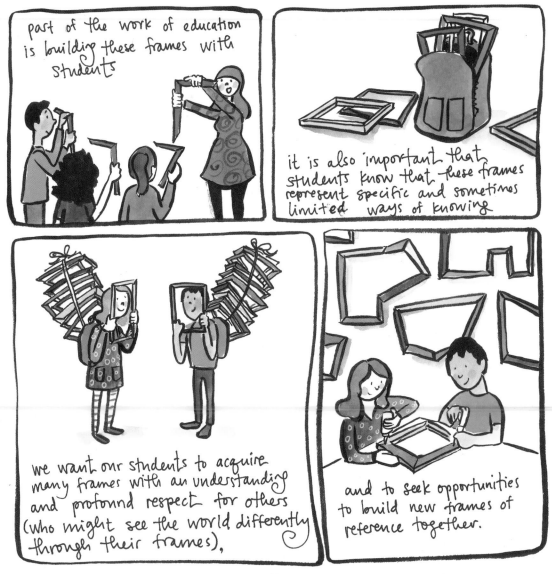

part of the work of education is building these frames with students

it is also important that students know that these frames represent specific and sometimes limited ways of knowing

we want our students to acquire many frames with an understanding and profound respect for others (who might see the world differently through their frames),

and to seek opportunities to build new frames of reference together.

209

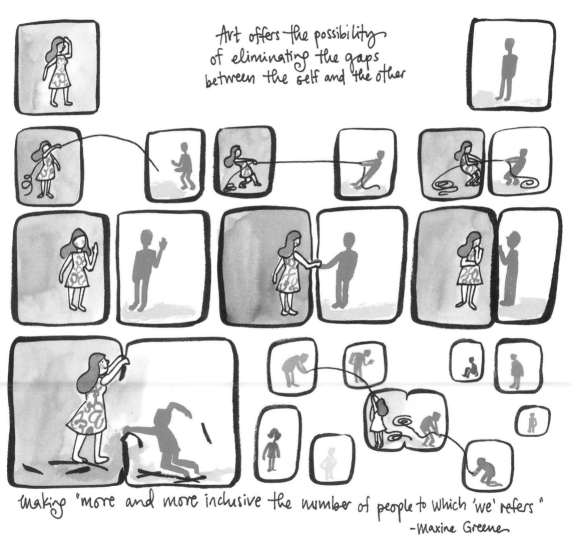

Art offers the possibility of eliminating the gaps between the self and the other

making "more and more inclusive the number of people to which 'we' refers"
—Maxine Greene

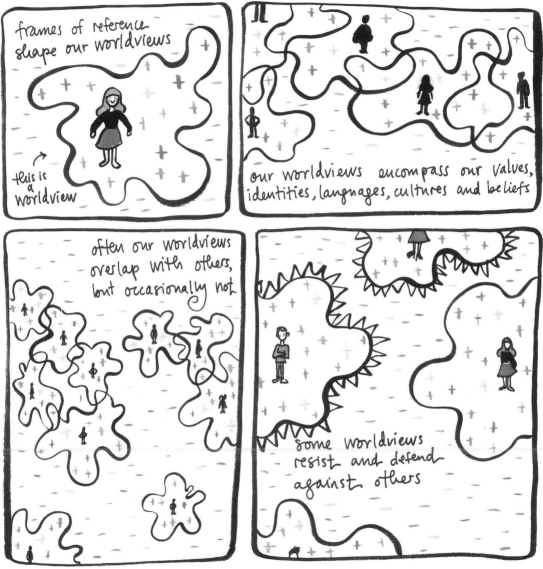

my hope is that through education these worldviews can become more porous and ever-expanding

broadening our ways of being in the world

fostering understanding and appreciation for that which is different

and increasing a sense of belonging

Conclusion

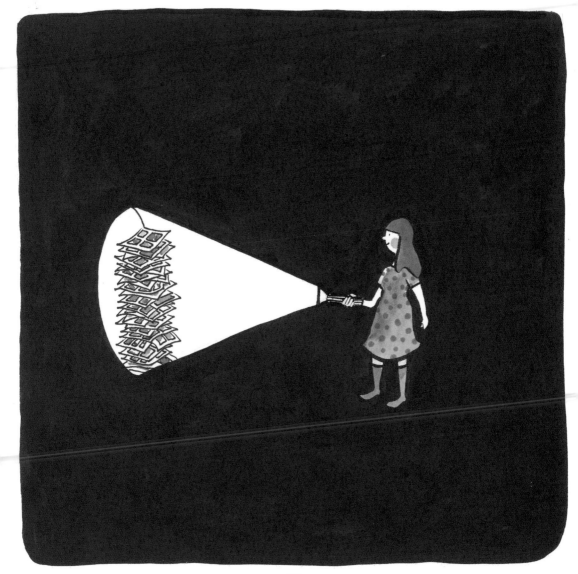

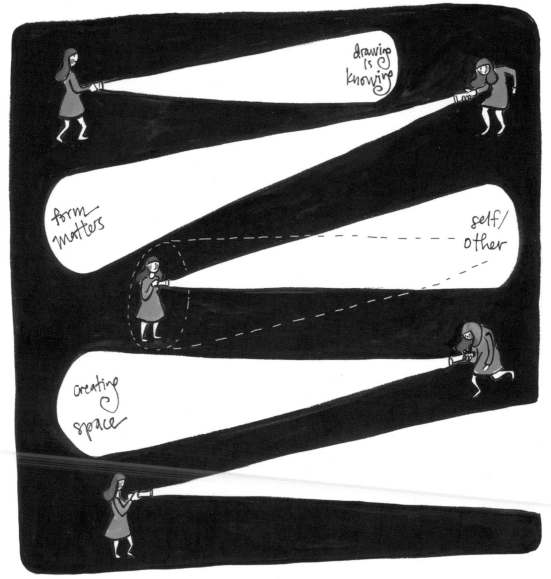

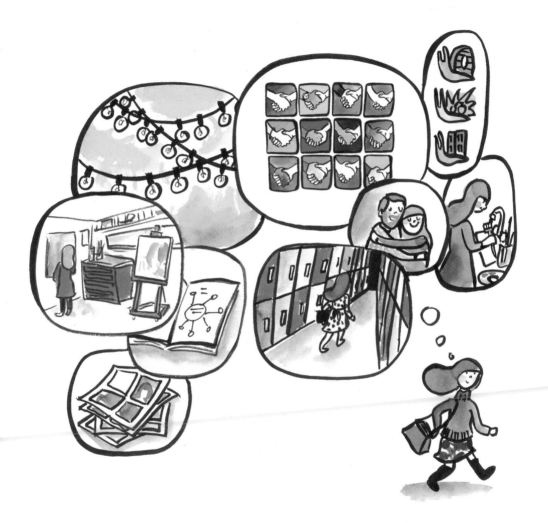

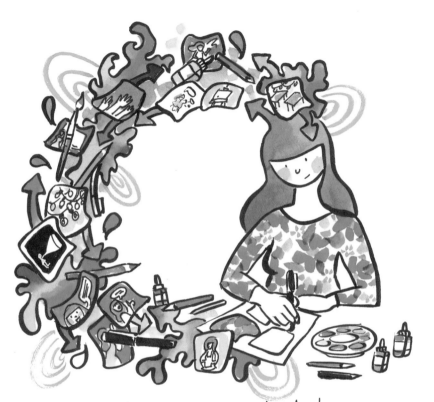

I don't create that which I already know,
I create in order to know, both the subject and myself.
I create to reveal, to bring into presence that which I
do not yet know, that which I may never know.

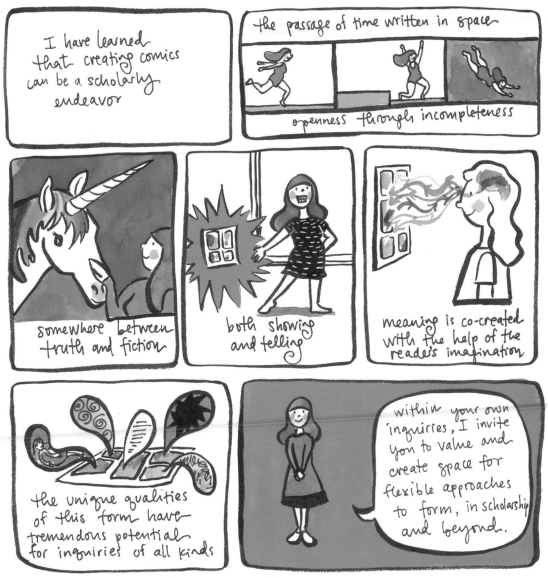

I have learned that creating comics can be a scholarly endeavor

the passage of time written in space

openness through incompleteness

somewhere between truth and fiction

both showing and telling

meaning is co-created with the help of the reader's imagination

the unique qualities of this form have tremendous potential for inquiries of all kinds

within your own inquiries, I invite you to value and create space for flexible approaches to form, in scholarship and beyond.

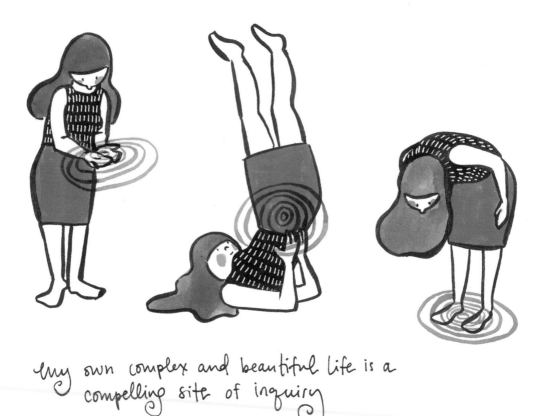

my own complex and beautiful life is a
compelling site of inquiry

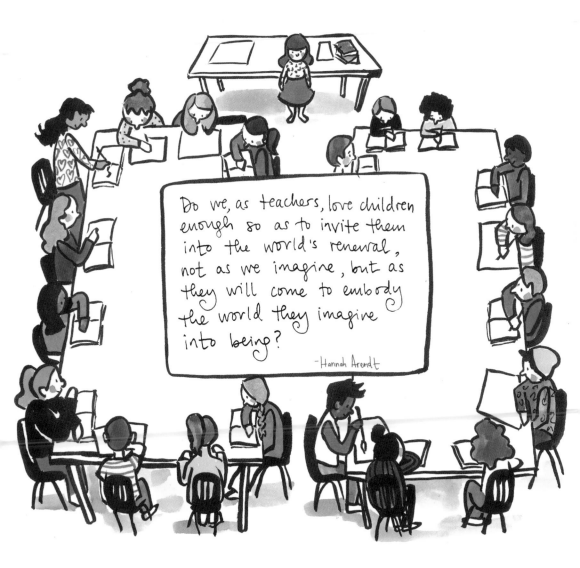

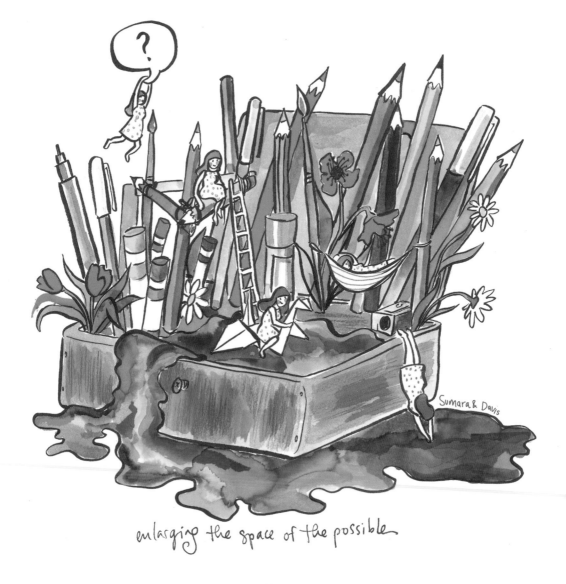

enlarging the space of the possible

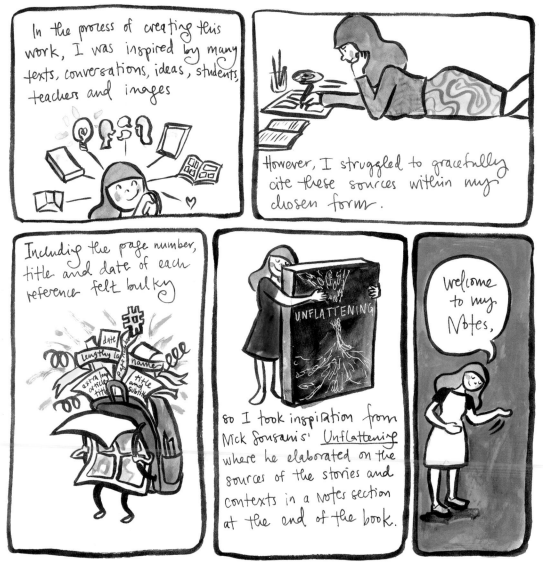

In the process of creating this work, I was inspired by many texts, conversations, ideas, students, teachers and images

However, I struggled to gracefully cite these sources within my chosen form.

Including the page number, title and date of each reference felt bulky

date
lengthy last name
extra long article title
title and subtitle
#

So I took inspiration from Nick Sousanis' Unflattening where he elaborated on the sources of the stories and contexts in a Notes section at the end of the book.

UNFLATTENING

Welcome to my Notes,

Notes

31 Sandra Weber and Claudia Mitchell, **"Visual Artistic Modes of Representation for Self-Study"** in **International Handbook of Self-Study of Teaching and Teacher Education Practices**, pp. 984 -986 (2004)

32 Sandra Weber and Claudia Mitchell, **"Visual Artistic Modes of Representation for Self-Study"** in **International Handbook of Self-Study of Teaching and Teacher Education Practices**, pp. 984 -986 (2004)

33 Sandra Weber and Claudia Mitchell, **"Visual Artistic Modes of Representation for Self-Study"** in **International Handbook of Self-Study of Teaching and Teacher Education Practices**, pp. 984 -986 (2004)

35 Nick Sousanis, **Unflattening**, p. 97, p. 117 (2015)

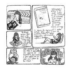

36 Elisabeth El Refaie, **Autobiographical Comics**, p. 4 (2012)

39 Maxine Greene, **Releasing the Imagination: Essays on Education, the Arts and Social Change**, p. 102 (1995)

42 Denis Donoghue via Maxine Greene, **Releasing the Imagination: Essays on Education, the Arts and Social Change**, p. 134 (1995)

46 Paraphrased from the quote "Through the arts we learn to see what we had not noticed, to feel what we had not felt, and to employ forms of thinking that are indigenous to the arts," Elliot Eisner, **The Arts and the Creation of Mind**, p. 12 (2002)

47 Elliot Eisner, **The Arts and the Creation of Mind**, p. 4 (2002)

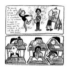

49 Celeste Snowber, **Landscapes of Aesthetic Education**, p. 68 (2009)

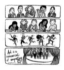

50 Paraphrased from Brian Eno, Kelly, Kevin, **Gossip Is Philosophy, Interview with Brian Eno**. Wired, (1995)
http://www.wired.com/wired/archive/3.05/eno.html

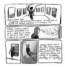

47 Maxine Greene, **Releasing the Imagination: Essays on Education, the Arts and Social Change**, p. 125 (1995)

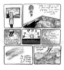

52 Michael Emme and Karen Taylor, "Sequential Art & Graphic Novels: Creating with the Space in-between Pictures", **StARTing With...** p. 93 (2011)
Vincent Van Gogh **The Starry Night** (1889)

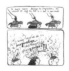

54 Maxine Greene, **Releasing the Imagination: Essays on Education, the Arts and Social Change**, p. 3 (1995)

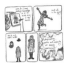 55 Celeste Snowber, **Embodied Inquiry: Writing, Living and Being through the Body**, pp. *xv*, 7 (2016)
Image Inspired by René Magritte, **The Pilgrim** (1966)

 56 Inspired by Celeste Snowber, **Embodied Inquiry: Writing, Living and Being through the Body**, p. *xiii* (2016)

 58 Maxine Greene, **Releasing the Imagination: Essays on Education, the Arts and Social Change**, p. 3 (1995)

 60 The following are my own self-portraits inspired by:
Pablo Picasso, **Seated Woman in a Red Armchair** (1931)
Vincent VanGogh, **Self-Portait** (1889)
Rube Goldberg, **Professor Butts and the Self-Operating Napkin**
Bill Watterson's **Calvin and Hobbes**

61 Barbara Kruger, **Untitled (Your body is a battleground)** (1989)
Raphael, **The School of Athens** (1509-1511)
Salvador Dali, **Portrait** (1954)
Guerrilla Girls
Johannes Vermeer, **Girl with a Pearl Earring** (1665)
Andy Warhol, **Self-portrait** (1968)
David Bowie, **Aladdin Sane** cover (1973)
Auguste Rodin, **The Thinker** (1840-1870)
Grant Wood, **American Gothic** (1930)

 62 I took inspiration for poetry in comics from Grant Snider's book **The Shape of Ideas**, www.incidentalcomics.com, He is a brilliant creator of comic poetry.
"Intelligence having fun" – Albert Einstein.
"experience is the medium of education" Elliot Eisner, **Arts and the Creation of Mind**, p. 3 (2002)

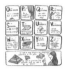

63 Paraphrased from Brian Eno, Kelly, Kevin, **Gossip Is Philosophy, Interview with Brian Eno**. Wired, (1995) http://www.wired.com/wired/archive/3.05/eno.html

64 Celeste Snowber, **Landscapes of Aesthetic Education**, p. 68 (2009)

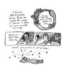

70 Maaheen Ahmed, **Openness of Comics: Generating Meaning within Flexible Structures**, p. 4 (2016)

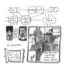

71 Inspired by Maaheen Ahmed, **Openness of Comics: Generating Meaning within Flexible Structures**, pp. 4 - 8 (2016)

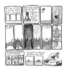

72 Scott McCloud, **Understanding Comics**, p. 66 (1993)
Nick Sousanis, **Unflattening**, p. 61 (2015)
Images: Ai Weiwei, **Dropping a Han Dynasty Urn** (1995)
Hokusa,i **The Great Wave off Kanagawa** (1832)

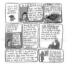

73 Scott McCloud, **Understanding Comics**, pp. 2, 9 (1993)

77 Marshall McLuhan, **Understanding Media: The Extension of Man**, p. 15 (1964)

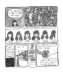
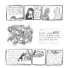
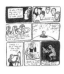
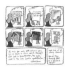
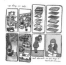
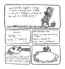
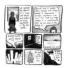

87 Molly Bang, **Picture This: How Pictures Work**, pp. 42 – 46 (1991)

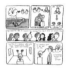

88 "Representation can be thought of, first as aimed at transforming the contents of consciousness within the constraints and affordances of a material."

"Representation stabilizes the idea or image in a material and makes possible a dialogue with it" Elliot Eisner, **The Arts and the Creation of Mind**, p. 6 (2002)

89 Elliot Eisner, **The Arts and the Creation of Mind**, p. 4 (2002)

90 Michael Emme and Karen Taylor, "Sequential Art & Graphic Novels: Creating with the Space in-between Pictures," **StARTing With...** p. 93 (2011)

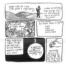

96 Karen Meyer, **Teaching Practices of Living Inquiry**, pp. 1, 2, 3, 8, 9 (2008)

97 Karen Meyer, **Teaching Practices of Living Inquiry**, pp. 1, 2, 3, 8, 9 (2008)

103 "Antlers of a moose are a bad place to hang your drippy clothes" came from a poem I had read that day by Shel Silverstein

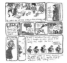

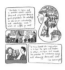

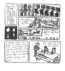

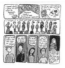

202 https://www.sketchbookproject.com

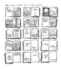

203 The drawings included are my interpretations of drawings created by my students; they are much better in the sketchbook!

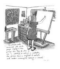

205 Rena Upitis, "**School Architecture and Complexity**," **Complicity: An International Journal of Complexity and Education**, *1* (1) p. 23 (2004)

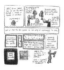

208 Elliot Eisner, **The Arts and the Creation of Mind**, pp. 84, 85 (2002)

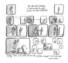

211 Maxine Greene, **Releasing the Imagination: Essays on Education, the Arts and Social Change**, p. 194 (1995)

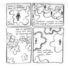

212 This concept came from a lecture delivered by Michael Ling in **Music Education as Thinking in Sound** course in summer 2016

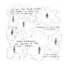

213 Lecture by Michael Ling in **Music Education as Thinking in Sound** course in summer term 2016

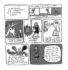

References

Ahmed, M. (2016). *Openness of comics: Generating meaning within flexible structures*. University Press of Mississippi.

Arendt, H. (2006). *Between past and future: Eight excersizes in political thought*. Penguin.

Bang, M. (2016). *Picture this: How pictures work*. Chronicle Books.

Barry, L. (2014). *Syllabus: Notes from an accidental professor*. Drawn & Quarterly

Brunetti, I. (2011). *Cartooning: Philosophy and practice*. Yale University Press.

Chute, H. L. (2010). *Graphic women: Life narrative and contemporary comics*. Columbia University Press.

Coupland, D. (2009). *Extraordinary Canadians: Marshall McLuhan*. Penguin Canada.

Eisner, E. W. (2002). *The arts and the creation of mind*. Yale University Press.

El Refaie, E. (2012). *Autobiographical comics: Life writing in pictures*. University Press of Mississippi.

Emme, M. J., & Taylor, K. (2011). "Sequential art & graphic novels: Creating with the space in-between picture." K. Grauer, R. L. Irwin & M. J. Emme (Eds.), *StARTing with...* (Third ed., pp. 92-93- 99). Canadian Society for Education through Art.

Fels, L. (2016). "Detailed course outline - Community, creativity & inquiry: Drama in education EDUC 852-5". Unpublished manuscript.

Fels, L., & Belliveau, G. A. (2008). *Exploring curriculum: Performative inquiry, role drama, and learning*. Pacific Educational Press.

Greene, M. (1995). *Releasing the imagination: Essays on education, the arts and social change.* Jossey-Bass.

Greene, M. (2001). *Variations on a blue guitar.* Teachers College Press.

Ling, M. (2016) "Porous worldviews lecture, music education as thinking in sound course". Unpublished manuscript.

McCloud, S. (1993). Understanding comics: The invisible art. *Northampton, Mass,*

McLuhan, M. (1994) *Understanding media: The extentions of man.* MIT press.

Meyer, K. (2008). "Teaching practices of living inquiry." Canadian Society for the Study of Education Conference.

Nachmanovitch, S. (1990). *Free play: Improvisation in life and art* Jeremy P. Tarcher/ Putnam.

Rice, P. (2014). *Soppy: A love story* Andrews McMeel Publishing.

Richardson, L. (1994). "Writing: A method of inquiry". *Handbook of Qualitative Research.* Sage Publishing, 1

Richmond, S., & Snowber, C. (2009). In Snowber C., SFU F. p. (Eds.), *Landscapes of aesthetic education.* Cambridge Scholars.

Snider, G. (2017). *The Shape of Ideas.* Abrams ComicArts.

Snowber, C. (2016). *Emobdied inquiry: Writing, living and being through the body.* Sense Publishers.

Sousanis, N. (2015). *Unflattening.* Harvard University Press.

Sumara, D. J., & Davis, B. (1997). "Enlarging the space of the possible: Complexity, complicity, and action-research practices". *Counterpoints, 67*, 299-312.

Upitis, R. (2004). "School architecture and complexity". *Complicity: An International Journal of Complexity and Education, 1*(1).

Wainwright, L. (2010). "Foreword". M. J. Jacob, & M. Grabner (Eds.) *The studio reader*. University of Chicago Press.

Weber, S. (2014). "Arts-based self-study: Documenting the ripple effect". *Perspectives in Education, 32(2), 8-20.*

Wardrop, A & Fels, L. (2015). "Stepping through the looking glass: Embodying hospitality through transitions". *Drama and Theatre Education: Canadian Perspectives in Education*, 32(2), 8-20.,

Weber, S., & Mitchell, C. (2004). "Visual artistic modes of representation for self-study". In J. Loughran, M. Hamilton, V. LaBoskey & T. Russell (Eds.), *International handbook of self-study of teaching and teacher education practices.* (Vol. 12 ed., pp. 984-986) Springer International Handbooks of Education.

Meghan Parker is an Art Teacher and Artist.
She lives in North Vancouver, Canada.